VENICE BEACH

Happy Birthday Nora
September 1987
Love Robert

VENICE

Introduction by
Charles Lockwood

ABBEVILLE PRESS
PUBLISHERS · NEW YORK

BEACH

Photographs by Claudio Edinger

For Lala

Designer: James Wageman
Editor: Walton Rawls
Assistant Editor: David Markus

Library of Congress
Cataloging in Publication Data

Edinger, Claudio.
 Venice Beach.

 1. Venice (Los Angeles, Calif.)—
Description—Views. 2. Venice (Los
Angeles, Calif.)—Social life and customs—
Pictorial works. 3. Los Angeles (Calif.)—
Description—Views. 4. Los Angeles
(Calif.)—Social life and customs—
Pictorial works. I. Title.
F869.L86V463 1985 979.4′94
85-4015
ISBN 0-89659-520-X

ACKNOWLEDGMENTS

For their friendship and advice, I would like
to thank Pamela Duffy, João Farkas, David
Markus, Donna Day, Justin Henderson,
Jay Colton, Marcia Grostein, Jonathan E.
Aviron, Don Weinstein, Harry Amdur, Phil
Vance, Greg Hassen, Rick Hassen, Ross
Lowell, Marvin Seligman, and Jennifer
Coley, Anne Edmondson, Kate Savage, and
Susan Filipek from Gamma-Liaison.

I am grateful to those at Abbeville Press,
especially Walton Rawls, my editor, Bob
Abrams, Dana Cole, Steve Pincus, Michael
Ritz, Sharon Gallagher, and Jim Wageman.

Finally, I would like to thank my family
for their love and unconditional support.

This book was made possible, in part,
because of the generosity of: Photo Impact
Lab. in Los Angeles; Modernage Lab. in
New York; E. Leitz, Inc.; Lowell Lights;
Ilford; and the Martin S. Ackerman
Foundation.

FOREWORD

Ever since I began photographing, it has been my aim to help people understand each other, to help end prejudices that we build up against those who are different from us.

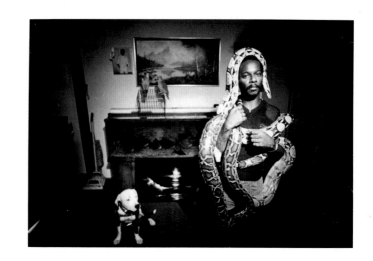

This book is meant as a celebration of a group of original individuals living in Venice, California. These are human beings that cannot be categorized by our common standards because they follow their own. They might be called eccentrics by those who have difficulty understanding them. But they have been a constant inspiration for me, either by their creative works as artists or by their unusual lives. They live freely; and while their existence will not stop wars or end the world's hunger, they no doubt make life on this planet more bearable.

And, of course, if generals and politicians of the world would juggle more chainsaws, play more with their pet snakes, or build more pyramids on the beach, the world would have more peace.

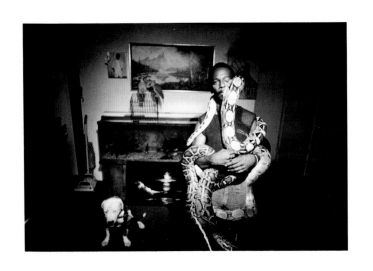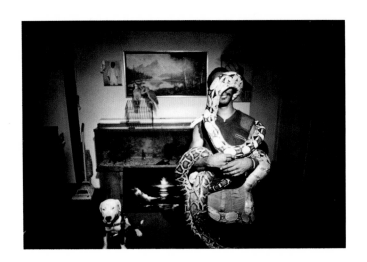

INTRODUCTION

Within Los Angeles's vast metropolitan sprawl, only one place is an often-creative and genuinely eccentric community, a curious historical spot, and a high-energy human circus, all rolled into one. This spot is Venice, a free-spirited, economically and socially diverse area of 40,000 residents, which stretches for a mile and a half along the Pacific Ocean between Santa Monica to the north and Marina del Rey to the south.

Venice is one of the few places in Los Angeles where people get out of their cars and walk around like residents of traditional East Coast and European cities, and thousands of Angelenos and out-of-town visitors fill the community on weekends to experience its unique color and flavor. Another of Venice's most obvious qualities is its "just-about-anything-goes" mood.

Elderly Jews, burnt-out hippies, and young men and women on the loose live in run-down three- and four-story hotels and apartment buildings along the beach. Since the 1970s, artists, writers, and growing numbers of affluent Bohemians have moved into bungalows on the narrow, garden-lined streets near the beach or along the remaining picturesque canals that originally gave Venice its name. Blacks and Hispanics live in the Oakwood district half a mile from the beach. And some Venice residents don't have homes at all: they simply park their cars or vans near the beach and live there for months, even years, before moving on.

Parts of Venice are raunchy and sometimes downright dangerous. But Venice is still a beach town, blessed with day after day of warm and sunny

weather, soft ocean breezes, and virtually smog-free air. Yet, in spite of all its attractions—indeed, because of them—Venice has its own problems. They are not unique to Venice. They are problems that confront any town when it is suddenly "discovered" by large numbers of people who hadn't known, or cared, that it was there. The old are dislocated by the young, the poor by the affluent, the traditions by the trends. People change slowly; places these days—places like Venice, anyway—change overnight.

Today, it is change that meets the eye. Some creative people have always been attracted to Venice. The late Charles Eames—designer, architect, and producer of films, although perhaps best known to the public for the Eames chair—worked in Venice for more than 30 years. But recently artists of every kind, discovered and undiscovered, have moved there. Painter Billy Al Bengston has a studio, and Tony Bill, co-producer of *The Sting*, lives and works in a beautifully renovated building half a block from the beach.

For some years, Venice has offered a full range of seemingly offbeat creative experiences, much as San Francisco did in the 1960s and New York's Greenwich Village in decades before. On one typical weekend, a visitor could attend the First Annual Venice Flute Festival, hear Argentinian jazz in a club, or enjoy the musician's showcase at the Meatless Mess Hall. Other artistic expression is even less structured. Murals appear almost overnight on blank walls of buildings. Street musicians draw large, enthusiastic crowds. Improvisational theater groups perform on the beach.

Along Ocean Front Walk, peddlers and street artists set up their stands in the vacant lots among the small apartment buildings, restaurants, and shops. And many of these small-scale entrepreneurs pursue their businesses with the same flair and creativity so typical of Venice.

One curly headed ex-teacher has sold paratrooper pants and brightly dyed surgical smocks from a red wagon with the help of her basset hound. A former social worker from Rhode Island offered Mexican sandals and baskets, and a linguistics student was known as Cactus Woman, because she sold only potted cacti.

But not all the street vendors have been young people in their twenties and thirties who have dropped out or pursued their sidewalk businesses as weekend sidelines. One grandmother sold attractive old clothing. "We don't call 'em antiques," she said on several occasions, "because we'd have to charge more money." Another Ocean Front Walk regular has been a spry woman in her eighties ("I am not going to tell you exactly how old") known as the Doll Lady. In good weather, she brings two aluminum chairs to Ocean Front Walk, one for her, the other for the large, cloth Raggedy Ann-type dolls she makes and sells.

Other peddlers sell food, and the aroma of cooking hot dogs and hamburgers, Mexican tacos and burritos, soul barbecue, and Texas chili fills the air along Ocean Front Walk. The Vegetarian Fast Food stand does a brisk business. For those less organically inclined, a man sells hot dogs from a truck that looks like a 15-foot-long frankfurter-in-a-bun on wheels.

Ocean Front Walk also has its share of suntanned, windblown vagrants

asking for spare change. Some are traditional big-city middle-aged winos. Others are young men and women who have used too many hard drugs. "No matter how sick, crazy, or screwed-up you are," one wild-eyed thirty-year-old panhandler remarked, "you can come down here and find someone sicker, crazier, and even more screwed-up, and you will see them and feel healthier by comparison."

Venice is also a mecca for the health- and fitness-conscious, ranging from the devoted vegetarians who shop at the various organic food shops to the professional male and female bodybuilders who work out at Gold's. In addition, Venice seems to attract the physically agile. In 1983 and 1984, Ocean Front Walk was a favorite spot for breakdancing. Several years earlier, it was the roller-skating capital of California.

On weekends, thousands of skaters jammed the broad sidewalk. Some skated up and down the mile-and-a-half-long promenade for hours. Others carried portable tape players and disco-danced down the pavement on their skates. A few held bubble-making devices and left hundreds of soap bubbles floating in their wakes. On Saturdays and Sundays, skaters turned a section of the pavement into an obstacle course with empty soft-drink cans for markers. When the police weren't looking, some young men put four or five garbage cans on their sides and jumped the entire row just like Evel Knievel.

Venice has always attracted the creative, the eccentric, the remarkable, and the free-spirited, starting with Abbot Kinney who founded the community at the beginning of the twentieth century. A millionaire who made his fortune

with Sweet Caporal and other cigarettes, Kinney was a renaissance man, educated in Europe, fluent in several languages including Latin, and world-traveled. His interests and energy knew no limits. He was a respected botanical expert, art and music fancier, even an occasional public servant. Sharing his knowledge and concerns with the public, he wrote dozens of books and pamphlets on a variety of subjects: *The Conquest of Death*, *Forest and Water*, and *Money*.

The handsome, bearded, piercing-eyed Kinney was a romantic as well. In 1904 he acquired 160 acres of marshland 14 miles west of Los Angeles and over-looking the Pacific Ocean just south of Santa Monica. The land reminded Kinney of the watery site of Venice, and he decided to build nothing less than a "Venice-of-America" on his land.

In August, 1904, Kinney's workmen started to excavate tons of dirt and sand for the Grand Canal (now Grand Boulevard), which was half a mile long, 70 feet wide, and four feet deep. Then they built an extensive system of 40-foot-wide, four-foot-deep canals several blocks from the beach, with Venetian-style bridges over them. The canal network tied into the ocean through two large pipes so that the tides, in theory, would freshen the canal system twice a day.

At the northeast corner of Ocean Front Walk and Windward Avenue, Kinney built the handsome St. Mark's Hotel, which was loosely modeled on the Doge's Palace in the original Venice. He specified that nearby commercial buildings should imitate the same Venetian style with street-level arcades, elaborate ornament, and pointed-arch windows. Then he built a 1,600-foot-long

pier into the Pacific Ocean at the end of Windward Avenue, with the Ship Hotel and restaurant near the end. In a departure from the usual Venetian motif, this structure resembled a Spanish galleon, but it rested securely on pilings rather than floating on the waves.

On June 30, 1905, Kinney's wife opened the floodgates, and the empty 16-mile-long canal network filled with seawater at the rate of 500 gallons a minute. Kinney then turned on the electric generating plant, and Venice basked in the glow of the 17,000 lamps he had installed along the streets, the pier, and the canals. Gas lines and sewers were already in place.

On July 4, 1905, more than 40,000 people rode the electric railroad from Los Angeles to Venice for the grand opening—an astounding figure considering that Los Angeles's population was only about 100,000 at the time. And the crowds loved what they saw: arcaded Venetian-style buildings, a 70-man orchestra playing at the end of the pier, and Italian gondoliers—imported from the real Venice— waiting to ferry wide-eyed visitors through the canals.

That year, Kinney sold hundreds of lots for permanent homes and beach cottages. Prices weren't cheap. Lots sold for as much as $2,700, twice the average price in another new subdivision, called Beverly Hills, two years later. Among the first to build was Kinney, whose home still stands on Cabrillo Avenue.

As a stylish real estate development, Venice was off to a good start. But the ever-romantic Kinney also wanted his fledgling community to become the center of art and culture in Southern California. To achieve this lofty goal, Kinney built a

3,500-seat auditorium at the end of the pier for the Chautauqua-like Venice Assembly. Finished just in time for the start of the season, the first year's program included performances by the Chicago Symphony Orchestra, lectures by Helen Hunt Jackson, author of *Ramona*, and two days of Sarah Bernhardt performing three celebrated roles.

Apparently, Los Angeles was not ready for such elevated cultural offerings. The Assembly lost $16,000 its first season. Instead, what appealed to the summer residents and the thousands of daytrippers was Venice's beach, romantic gondola rides, and pleasant restaurants and beer gardens—all within a 25 cent railroad trip from Los Angeles.

Knowing when to quit, Kinney canceled plans for the Assembly's following season and stopped talking about founding a university at the edge of town. Now, he began turning Venice into the seaside amusement park that the public wanted.

When the Lewis and Clark Exposition closed in Portland, Oregon, Kinney bought most of the amusement rides and installed them as part of a multibuilding Midway-Plaisance that he opened along the Venice Lagoon in January, 1906. After that, he built Ocean Front Walk along the edge of the beach, and it was just as popular a promenade then as it is today. Next came The Speedway, a 20-foot-wide bicycle course, located half-a-block inland from Ocean Front Walk and extending from one end of Venice to the other.

By 1914, Venice offered something for everyone—band concerts on the pier, dances in the old Assembly hall, 10 cent camel rides, hootchy-kootchy

shows in the Midway-Plaisance, even airplane barnstorming in the skies. In 1915, more than 60,000 spectators watched Barney Oldfield win the First Annual Venice Grand Prix, a 300-mile-long auto race through the streets of the town. (Because of the large number of accidents, it was also the Last Annual Grand Prix.) Despite this honky-tonk atmosphere near Ocean Front Walk, Venice also became a respectable resort and year-round community, and hundreds of middle-class families built comfortable homes close to the beach or along one of the canals.

In those days when silent film directors shot their movies in authentic locations rather than at studio lots, Hollywood quickly discovered Venice as well. During 1914, Keystone Kops creator Mack Sennett heard about an upcoming children's auto race in Venice. This sounded like a wonderful opportunity for slapstick comedy, and Sennett told an unknown comedian he had just hired, named Charlie Chaplin, to go to the auto race and create as much confusion as possible for racing officials and the spectators.

Chaplin wore a funny-looking costume to the races—pants several sizes too large, shoes too big and on the wrong feet, a too-small bowler hat, and a false moustache. He improvised slapstick routines at the auto race for 45 minutes, and the result was an 11-minute comedy short entitled *Kid Auto Races at Venice*. This was the second film Chaplin ever made, and it was the beginning of his famed "Tramp" character.

In the late teens and early 1920s, Venice reached its apogee as a place to live and as a seaside resort. Venice, for instance, was the first section of Los

Angeles that veteran journalist Thomas D. Murphy "visited" in his 1921 book, *On Sunset Highways. A Book of Motor Rambles in California.*

At the same time, however, Venice was becoming typecast as another Coney Island. As Murphy declared: "To one who has lost his boyish zeal for 'shooting the shoots' and a thousand and one similar startling experiences, or whose curiosity no longer impels him toward freaks of nature and chambers of horror, there will be little diversion save the multifarious phases of humanity always manifest in such surroundings. On gala days it is interesting to differentiate the types that pass before one, from the countryman from the inland states, 'doing' California and getting his first glimpse of a metropolitan resort, to the fast young sport from the city, to whom all things have grown common and blasé and who has motored down to Venice because he happened to have nowhere else to go."

When Thomas D. Murphy published his 1921 edition of *On Sunset Highways*, Venice's good years were clearly numbered—and not just because of the increasing mood of a Coney Island. Fires and winter storms periodically damaged the pier and Midway-Plaisance. The canals, it turned out, did not flush out with every tide, as Kinney had anticipated. Indeed, they were filling up with silt, algae, and even garbage. Finally, scandals rocked the town government, which provided inadequate police, fire, and sanitation services.

Venice might have overcome these simultaneous troubles if founder Abbot Kinney had been present. But he had died on November 14, 1920, and much of Venice's optimism and spirit died with him.

As if admitting their town's failure, residents voted 3130 to 2215 to become part of Los Angeles in 1925, with the hope, as one annexation supporter declared, to "generally drag poor, blessed Venice out of the gutter."

This did not happen. Community services remained as haphazard as ever. Los Angeles's one accomplishment was to fill in all of the seven original canals. This outraged thousands of residents. When the first truck started dumping dirt into drained Coral Canal (now called Main Street), nearby residents jumped into the empty ditch and frantically shoveled dirt out as fast as it poured in. But their anger was futile. Several months and 80,000 cubic yards of dirt later, all of the canals north of Venice Boulevard had vanished.

Shortly after the canals were destroyed, Venice suffered another, even more serious, blow to its distinctive charm. On December 18, 1929, the Ohio Oil Company struck oil on the southern edge of the community. Two years later, some 300 oil wells were pumping noisily away. Entire streets vanished under a forest of wooden oil derricks, and a grimy film of oil coated Venice's bungalows and palm trees. Tourism dropped, and middle-class families started fleeing the town.

Even in these bleak Depression and postwar years, Venice was not totally unloved and unwanted. Retired couples on small fixed incomes and black and Hispanic families from the downtown Los Angeles ghetto were happy to live in Venice. Although the housing was decaying and the beach was closed because of raw sewage pouring into the ocean, these newcomers had found a comfortable, cheap, safe place to live.

But tranquility has never been one of Venice's virtues, particularly in the blocks near the beach. During the late 1950s, Venice—or Venice West, as it was called—had become Southern California's Beatnik capital. Venice "squares" were horrified. They had always tolerated some eccentricity in their community —they really didn't have much choice—but the Beatniks had gone too far.

The Venice Civic Union was formed to clean up the town, and in 1962 the City of Los Angeles condemned the St. Mark's Hotel and the Gas House—a hangout where the habitués sat on pillows on the floor or in one of the bathtubs scattered around the main room, rapping endlessly, playing bongos, and smoking dope. Safety officials tore down the Gas House early one Sunday morning without going through the lengthy and public process of obtaining a demolition permit. Despite the continuing harrassment, the Beatniks did not disappear until their movement ran out of momentum on its own in the mid-1960s.

By then, hippies, flower children, and borderline crazies who had done too many drugs too often were moving into the hotels and apartment buildings along the beach, into the run-down and often-unheated shacks along the silt-filled canals, and even into long-empty storefronts on deteriorating commercial streets. Venice had finally become a seaside slum, and, for the first time, large sections had become depressing to look at and dangerous to live in.

Just when Venice's future seemed bleakest—there was even some talk about urban renewing much of the community out of existence—the first tentative signs of improvement happened in the early 1970s. "The pervasive decay and the

down mood could not totally obscure Venice's undeniable charm," declares Randy Harrison, who lived in Venice and made jewelry for a year after graduating from the University of Southern California dental school in 1975. "Actually, Venice had become the most romantic spot in Southern California. The half-gone Venetian arcades, the crumbling sidewalks and decaying bridges along the canals, even the algae-choked, half-empty canals themselves—all these had an appalling yet quite picturesque beauty in a plastic, fast-moving Los Angeles, where charm was something manufactured for amusement parks or 'Olde English' restaurants."

"Although my friends and I talked a lot about self-exploration and self-expression—and sometimes took steps in those directions—Venice of the 1970s also represented a place and a time to have fun," continues Randy Harrison, for the past 10 years a dentist in rustic Topanga Canyon near Malibu. "My friends and I spent our days going to the beach, shopping the junk stores on Main Street and West Washington Boulevard before they became chic, having potluck dinner parties with neighbors, making an occasional far-out home movie, or dancing at the local bar. We led a casual unpretentious lifestyle in Venice that was quite separate from the 'nine-to-five' mainstream and didn't require a lot of money."

At the same time, successful yet adventuresome artists, writers, and movie people discovered Venice's eccentric but undeniable charms in the 1970s. "That's when I moved to Venice," recalls actor, producer, restaurateur Tony Bill. "I'd never lived there, but I knew plenty of people who did, and the community suited my tastes. The air was clean. I was stimulated by the many interesting people, the

variety of people. And Venice was close to my sailboat. But once I moved in, I discovered that some of my Hollywood and Beverly Hills friends wouldn't visit me here. Too dangerous, they said, and they may have been right."

But the public perception of Venice—and the physical reality of the community—changed rapidly in the late 1970s. Suddenly, Venice acquired a raffish sort of chic. Just consider what happened to the once-derelict block of Market Street off Ocean Front Walk where Tony Bill opened his production office. By 1980, artist DeWain Valentine worked next door; Robert Graham, the sculptor, had his studio around the corner. Across the street, the Ace Gallery showed Robert Motherwell, Andy Warhol, and Robert Rauschenberg. Actor Richard Dreyfuss opened a production office down the block.

This block of Market Street typified the vast and rapid improvements sweeping Venice in the late 1970s and early 1980s. The change was particularly clear in the blocks near the beach, which were the last chunk of low-rent ocean-front real estate in Southern California. Dozens of stylish restaurants, antique shops, and art galleries opened along Main Street in Ocean Park, a little community between Venice and Santa Monica. Main Street had become a Los Angeles version of San Francisco's Union Street or Georgetown in Washington, D.C. Sleek, affluent-looking people from Beverly Hills or Marina del Rey, who wouldn't have dreamed of setting foot anywhere near Venice a year or two earlier, couldn't find empty parking spaces for their Mercedes or Porsches along Main Street most nights of the week.

The improvement boom even spilled over into parts of West Washington Boulevard, the dividing line between the ocean-front community and the black and Hispanic neighborhood of Oakwood. But one West Washington Boulevard landmark remained the same: Rose Cline's U-Need-It Shop on the block just north of Venice Boulevard. Rose is short, suntanned, feisty, sixtyish, and her shop continues as a fixed-location, seven-days-a-week garage sale. "I've got an entire Yellow Pages here," Rose often says with a smile. "There's nothing I won't buy, and nothing I won't sell."

Although parts of Venice now offered affluent Angelenos new places to shop, eat, and attend gallery openings, many residents regretted the changes in the community. "In the late 1970s, Venice became too much of a tourist attraction," recalls Randy Harrison. "So many outsiders inundated Ocean Front Walk and Main Street that they—and the subsequent 'boutique-ization' wave —displaced the genuinely creative, free-spirited, offbeat places and people that they were coming to see."

On Venice's residential sidestreets, escalating house and apartment rents inflicted cruel hardships on the community's aged and poor. "I've lived in the same one-bedroom apartment on Sixth Avenue in Venice since 1959," said handsome, gray-haired widow Esther Gilman in 1980. "But I don't know how much longer I'm going to be able to stay here, because the landlord keeps raising the rent." Unable to find another apartment that she could afford, Esther Gilman applied for housing in one of the two subsidized buildings for the elderly in

Venice. The two buildings had a total of 110 apartments. The waiting list was
4,000 names long.

Despite the often-traumatic changes in the past decade, Venice's creativity, beach-town ambience, and anything-goes spirit still endure, and these qualities continue to attract countless Angelenos and out-of-towners, whether they are afternoon visitors or become new residents. Among those who have recently fallen under Venice's spell is Claudio Edinger who lived on Ocean Front Walk from July through September, 1984, while he photographed the extraordinary variety of men and women depicted in this book.

"With all these different people living together," Edinger declares, "Venice may be (as one fellow said) the best attempt yet to make democracy work—even though everyone doesn't always get along harmoniously all the time."

"For me, Venice also seems like the quintessential California microcosm," Edinger continues. "Among the many 'originals' living in this community, there's a deep concern for spiritual values and personal growth. And there's real creativity, and it is directed toward art, film, muscles, or simply having a good time. Maybe all this is a little superficial at times. But some residents are experimenting with entirely new ways of thinking and living, whether they realize this or not. That is their gift, and Venice's gift, to the rest of us."

—*Charles Lockwood*

VENICE BEACH

Rad Ish

*Ish is a leader of a rock band named
R. I. P. "I love Venice because people here
are weirder than me—so I am sort of
incognito," he says. His name means
"radically selfish," and his goal in life
is to shock people. "I'm not sitting
here passively," he asserts. "What are
you doing?"*

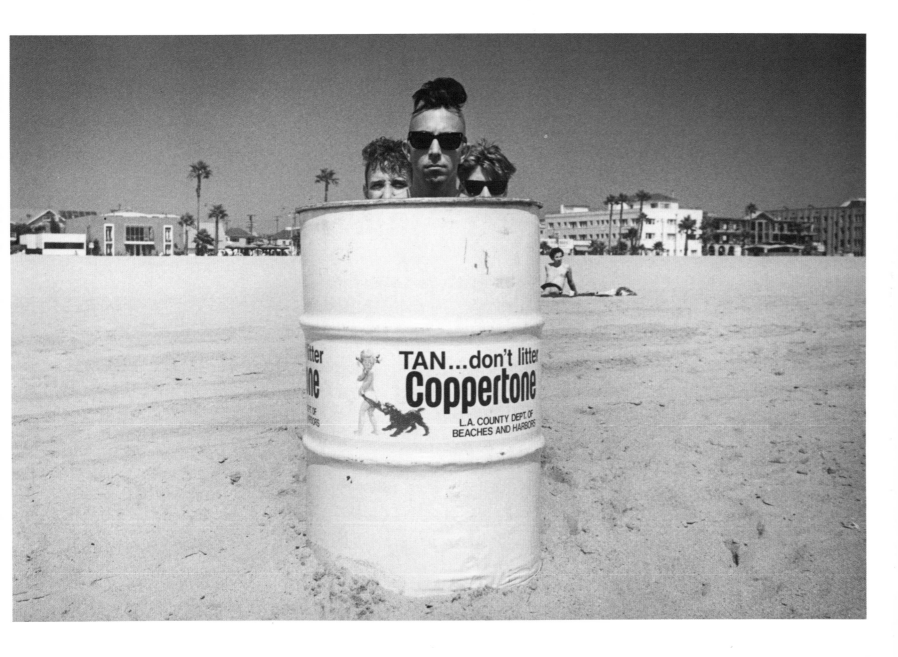

Tom Sewell

This former art director, gallery owner, and salesman of Fuller brushes, invented the "Pickle Mobile." He covered his old Studebaker with polyurethane, "and it looked like a pickle." He also has been a painter for topless dancers and sold a photo essay to Life *magazine depicting the delirious adventures of a friend who one day discovered a mistaken deposit of $500,000.00 in his checking account.*

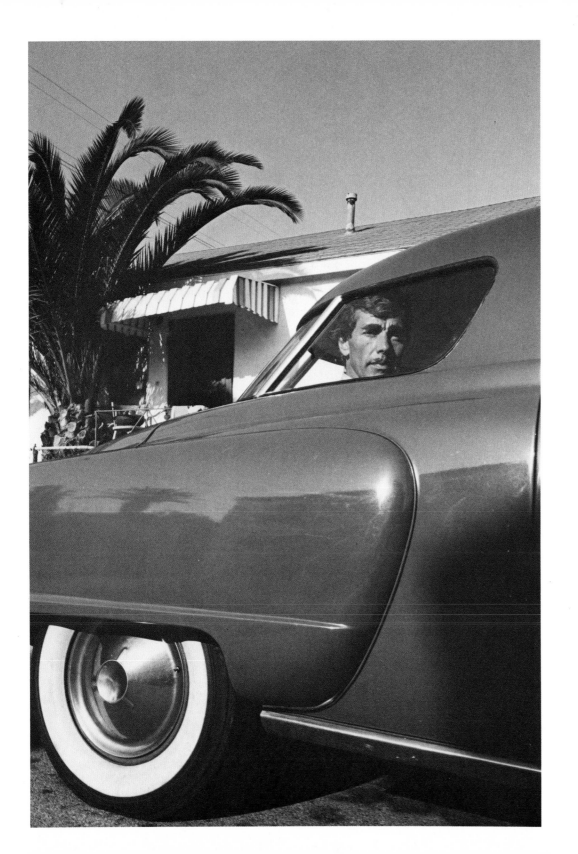

28 Terry Hershey

Trained as a nuclear engineer, he has been building pyramids on the beaches of Venice every Saturday for the last ten years. "I like Venice because people here appreciate my work." He began building pyramids after seeing the King Tut exhibit.

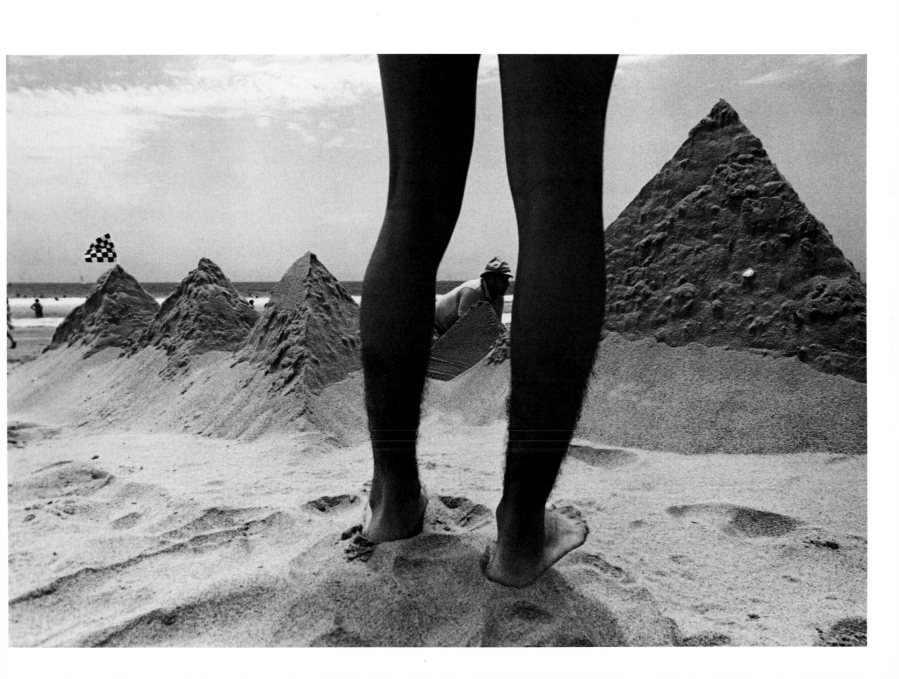

Lisa Lyon

A performance artist, she has been photographed for several books, including a book about her entitled Lady. *A TV producer, she has also studied voice, guitar, flamenco, martial arts, painting, and sculpture. "I try to encourage people to look at their brightest side," she says.*

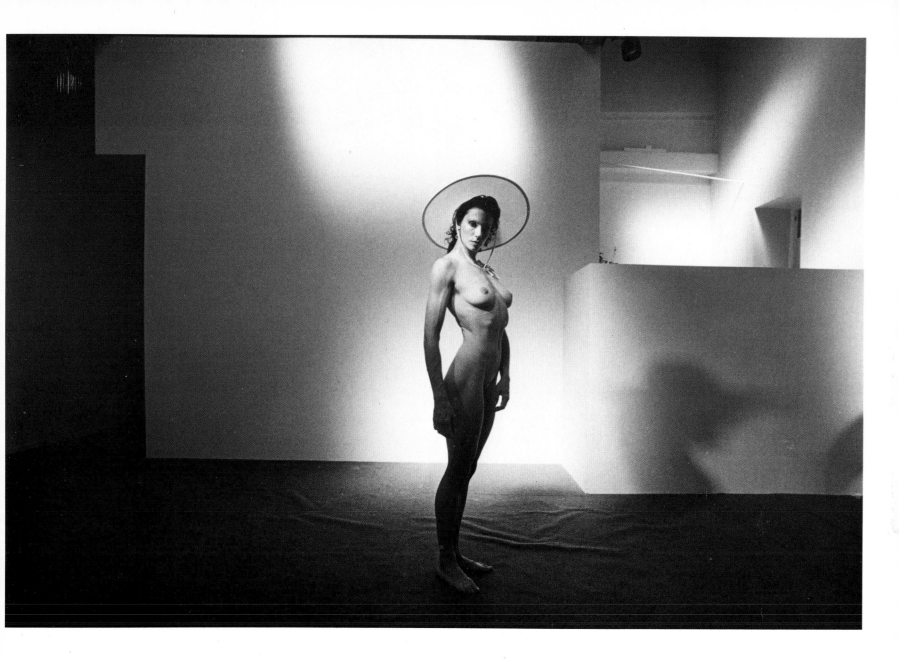

David Lee Bynum

He claims his street performances are the
"longest-running show in Hollywood."
Born in Florida, he started singing at
age six.

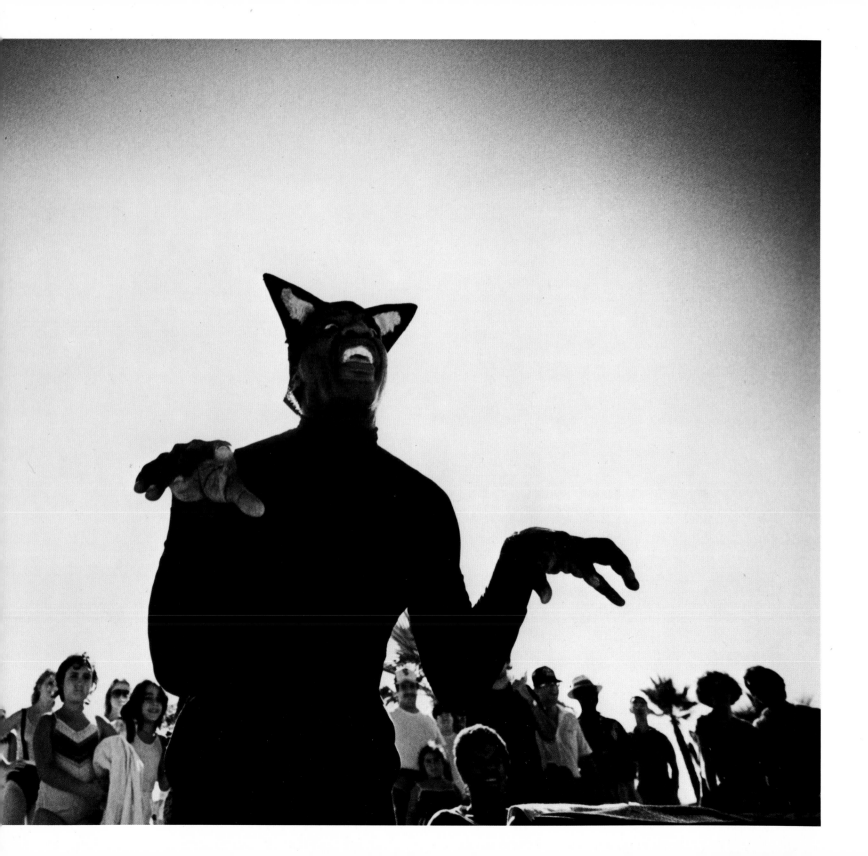

Natasha Hankle and John Hayden

She is an ex-Playboy Playmate, and he is an actor. His most notable role was in Valley Girl. *John wants to continue in acting, and Natasha would like to go into word processing. They've been together since high school.*

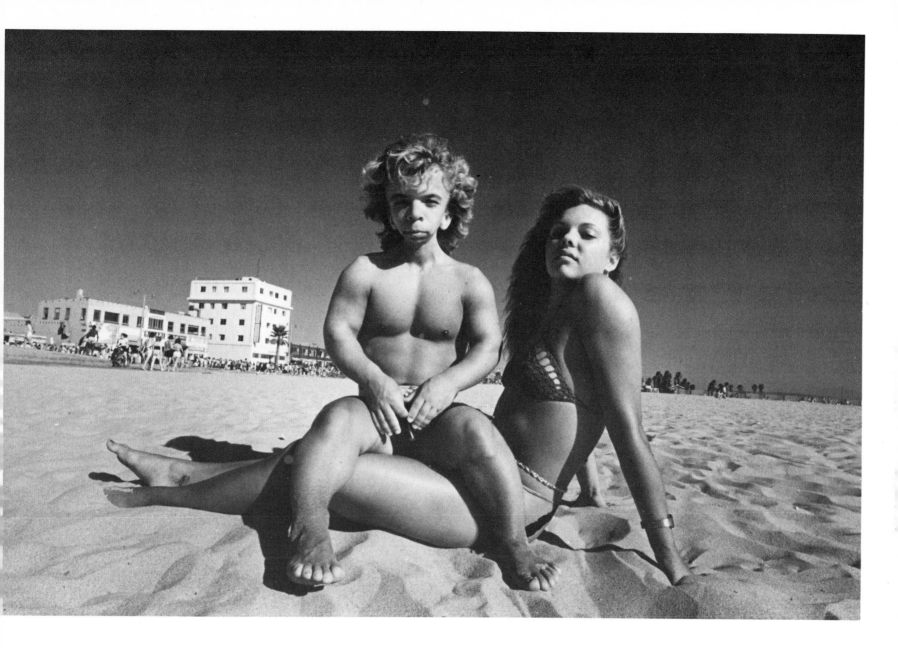

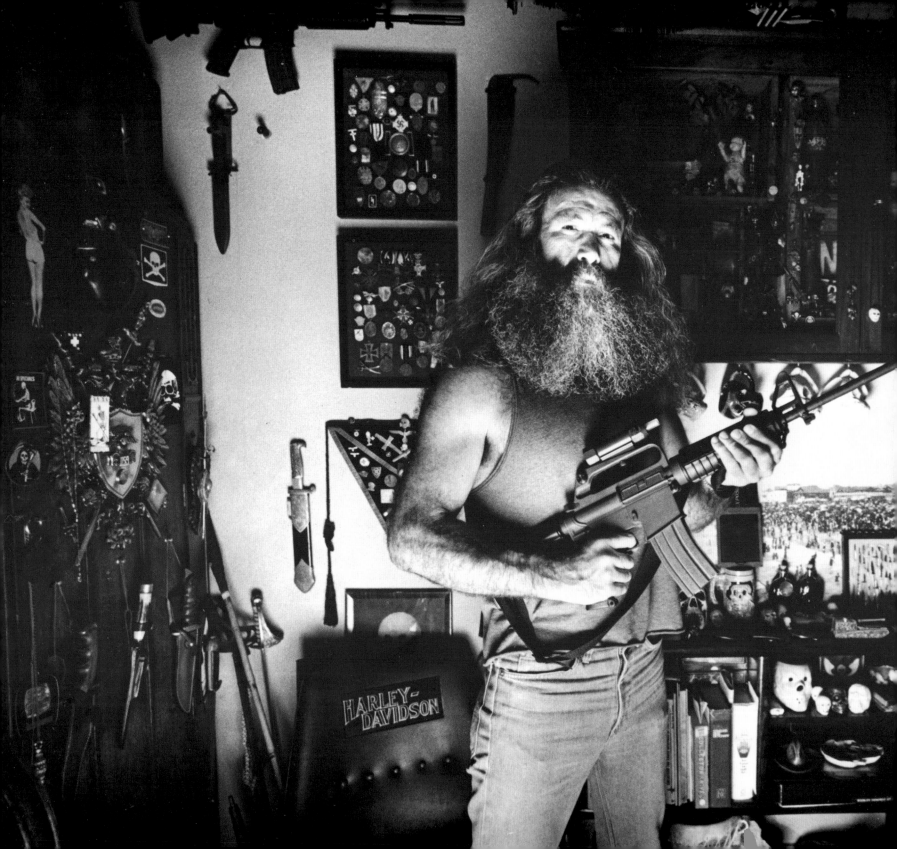

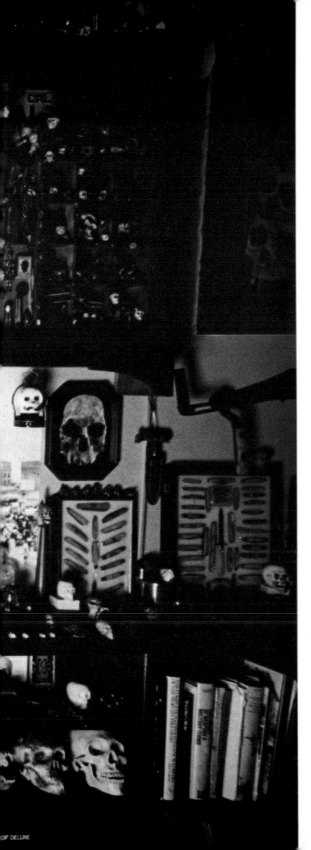

John Jones

A collector of guns, skulls, knives, and
teddy bears, Jones was born into a Jewish
family in Tunisia. He has been in Venice
since the early sixties. "It was the place to
tune-in and drop-out," he says. He is also
a motorcycle enthusiast and plays the
congas. His father is a chiropractor.

Tasha

This sixteen-year-old "new waver" hopes to work as a recording engineer. "People often insult me on the streets, saying things like 'you gross punk, you think this is Halloween?' But I'm not about to change my life-style because of that." She adds, "If we all looked the same, we'd be a bunch of clones."

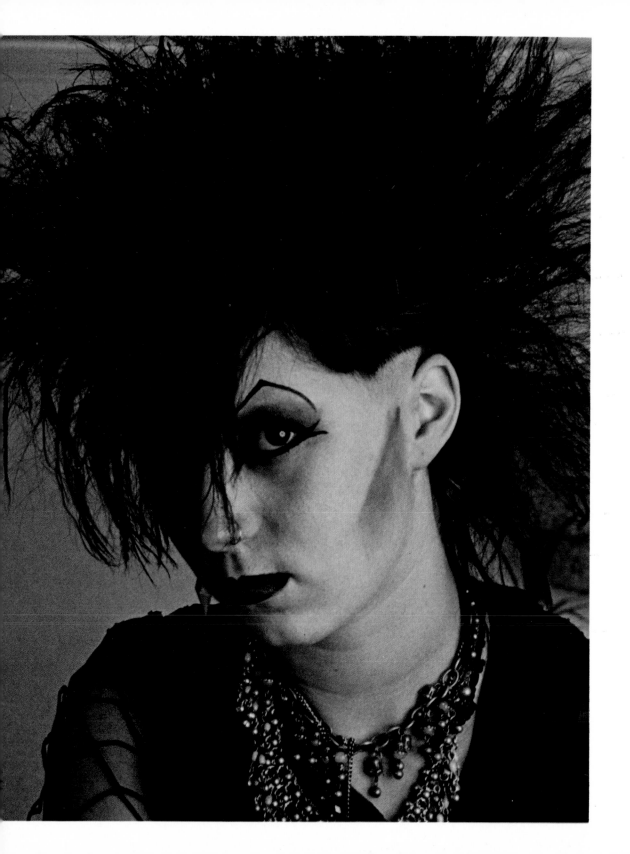

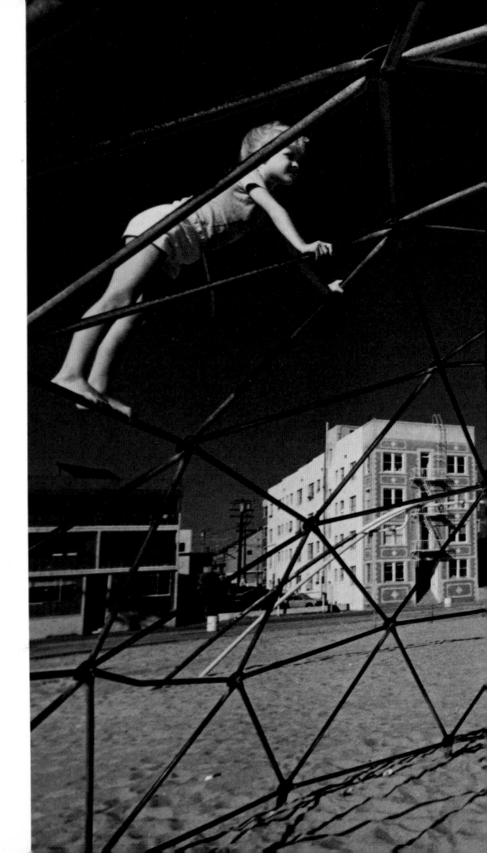

40 Tony Braithwaite

A sound engineer, he believes that hanging upside down is the secret to a long life. "It changes the force of gravity on your body; it strengthens your back, fortifies your organs, and helps stop sagging and aging," he says. "And you see the world in a better perspective."

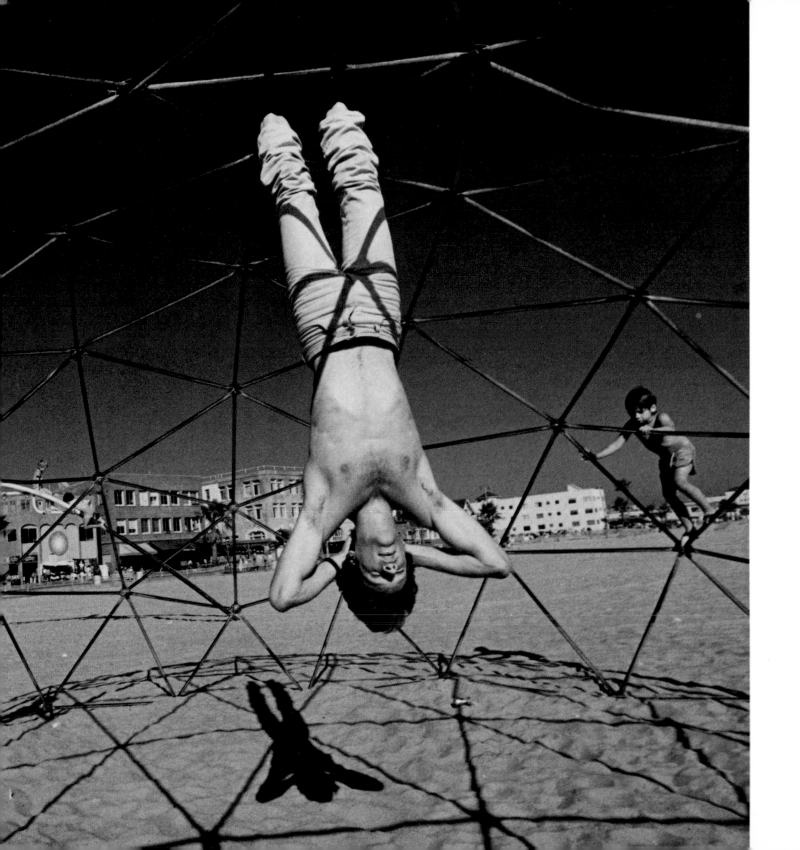

Jeff Howe and Gigi Rene

He's twenty-one and eats about eight meals a day. The current "Mr. Arizona," Jeff owns a suntanning and body wrapping salon in Phoenix. Gigi has been a "Barely Legal Calendar Girl," "Miss English Leather Bikini," and she won a trip to California as a prize in a "Pony Express" bikini contest. She's also a dental assistant and is trying to be a firefighter. Both are registered Republicans.

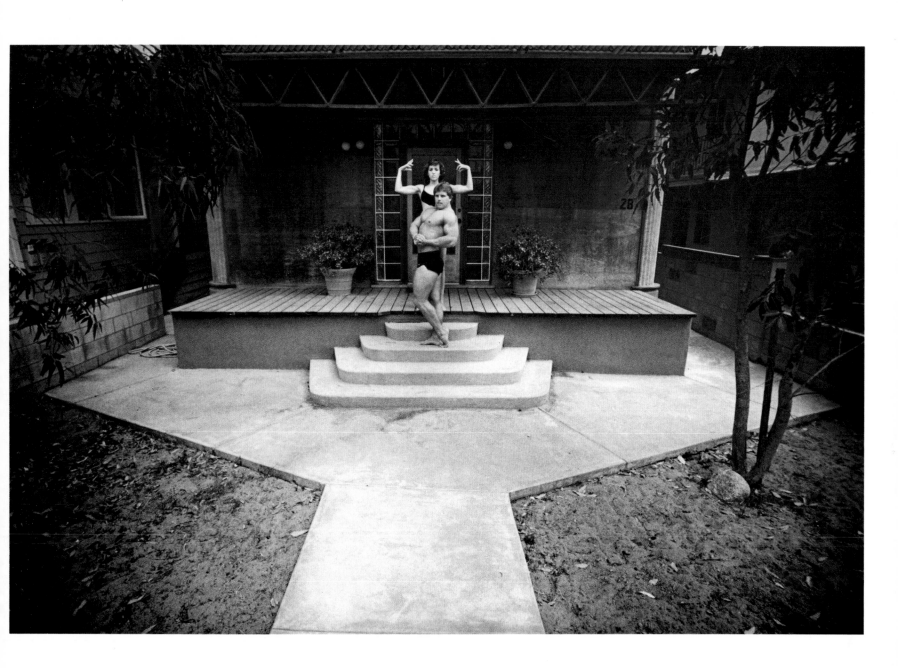

44 Tony Bill

At age twenty-two, he starred with Frank Sinatra in Come Blow Your Horn. *Now a producer and director—he produced* Taxi Driver *and* The Sting—*he remembers when his friends were afraid to come visit him in Venice. With Dudley Moore he has started a restaurant across the street from his home. "I don't like to drive to work," he says.*

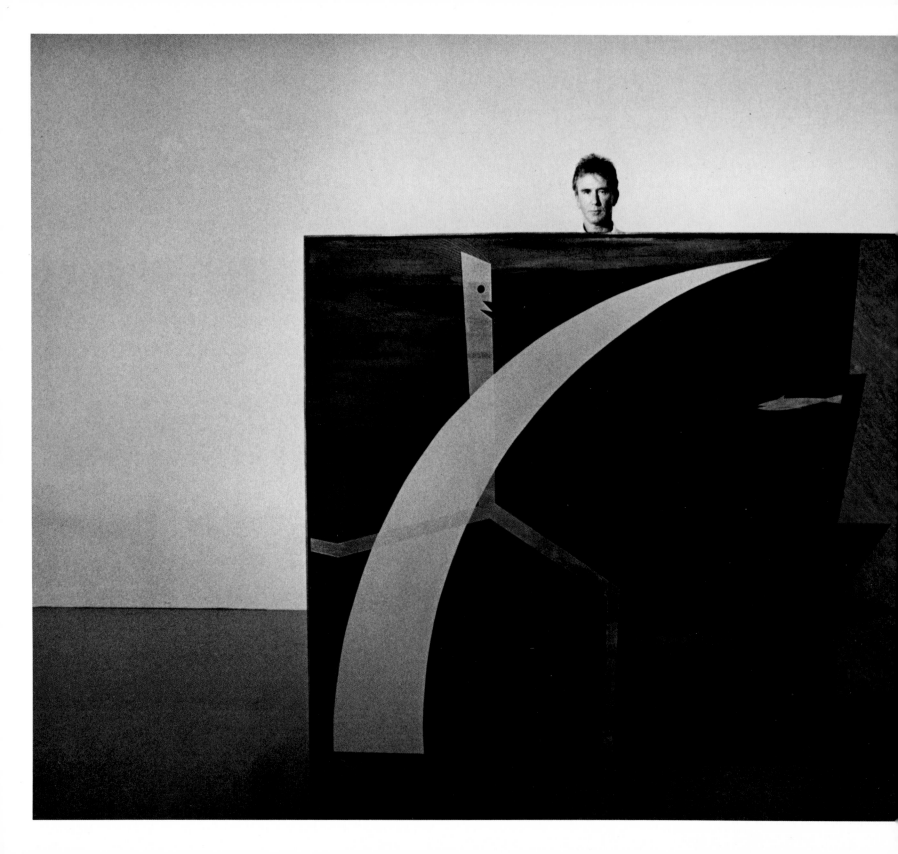

*He moved to Venice 25 years ago for the
cheap rent. His paintings have been shown
in some of the world's best-known museums.
"Painting is mostly drudgery," Bengston
complains. "It's absolute work, until you
get a stroke of genius." He was an athlet-
ics major in college.*

48 Hispanic family at
the Boardwalk showers

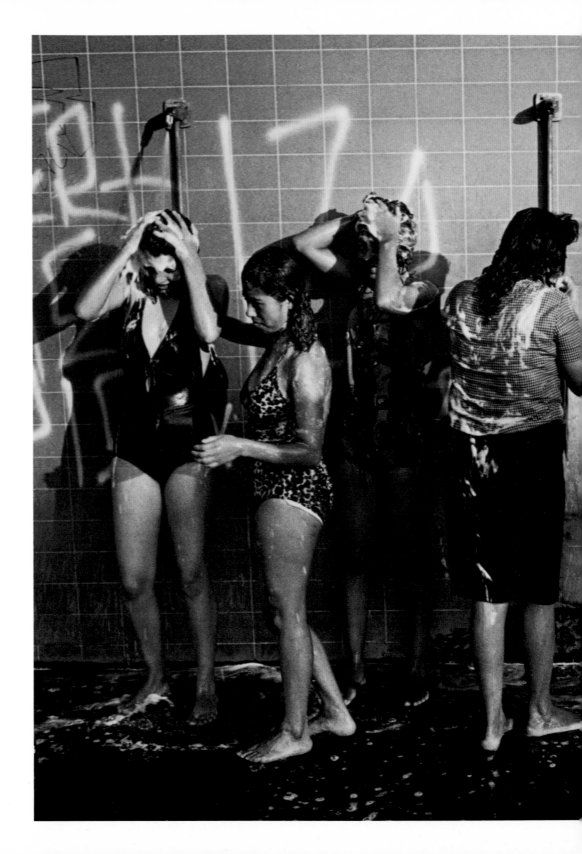

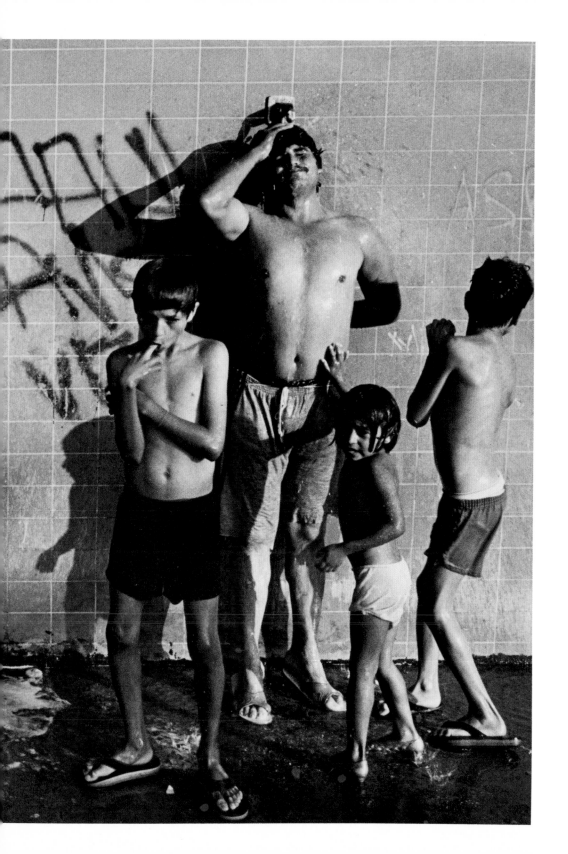

Kenneth Bapties

A Venice native, he says it was a rough place to grow up because of the gang fights. A former member of a motorcycle club, he broke his leg in a fall and had to sell his bike to pay for the hospital bills. He is now a roofer and lives along the canals in a "haunted van" that he purchased from a woman whose son had died in the vehicle. "Once when I was asleep, all the doors flew open at the same time. Nobody was around. It scared the hell out of me," he says.

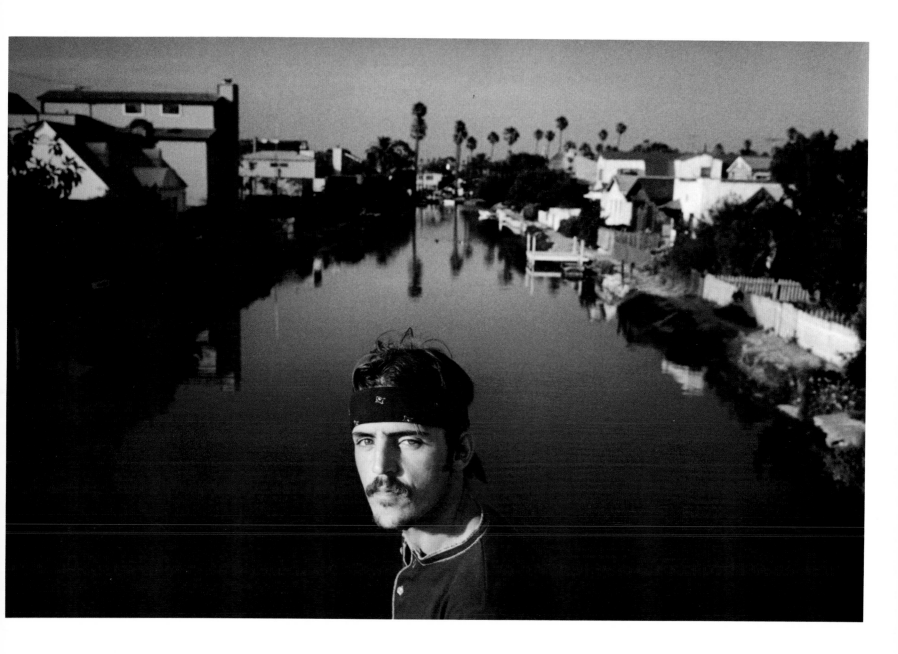

Eric and Elizabeth Orr

A painter and sculptor, he has lived in Venice for the last 16 years. The materials he uses for his work include: leaded gold, light, water, human carbon, negative ions, silence, human blood, and ground up AM/FM radio. "My ambition is to make my art as simple as the concept of zero," he says.

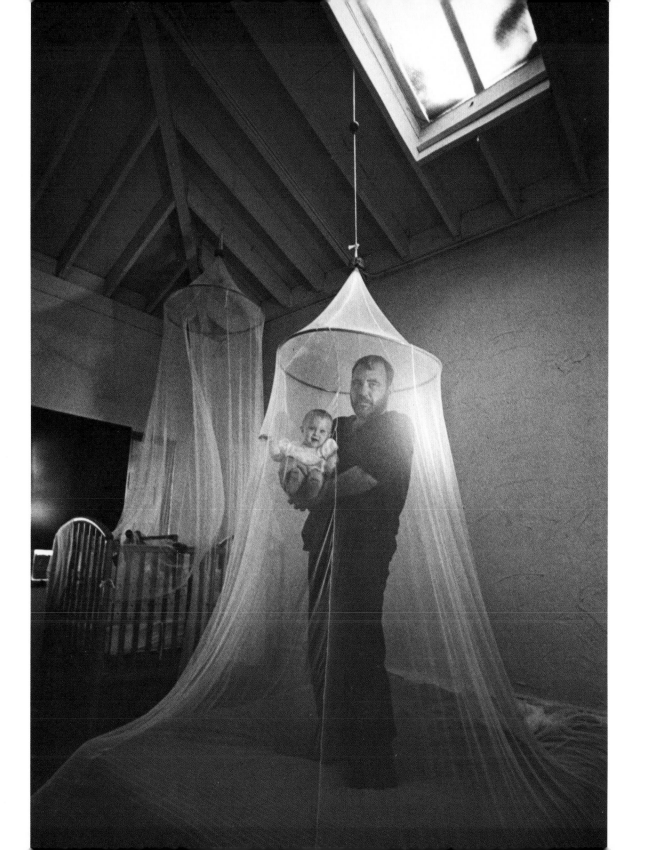

54 Vincent Rogers and Cassandra Wyatt

He sets up shows at the Santa Monica Auditorium, and cleans up after they're over. She goes to Venice High and wants to work as a receptionist at the airport. "I like talking on the phone," she says. "And I don't want to be a stewardess, because I want to get married. And if I be flying all over, I'll have no time for my man."

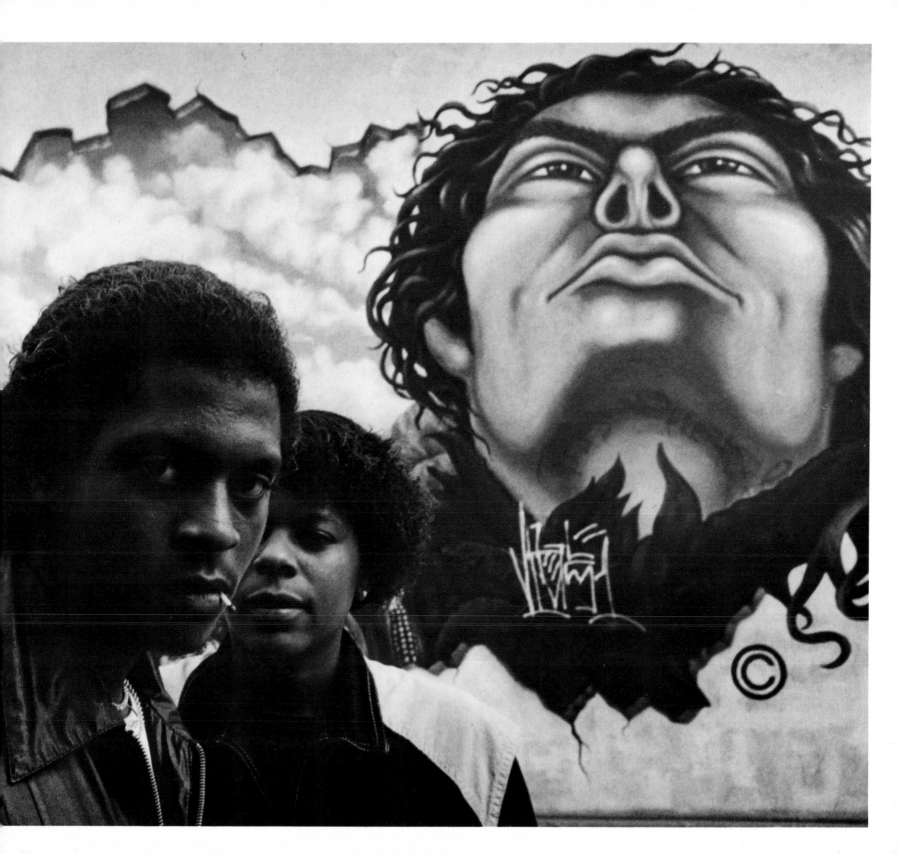

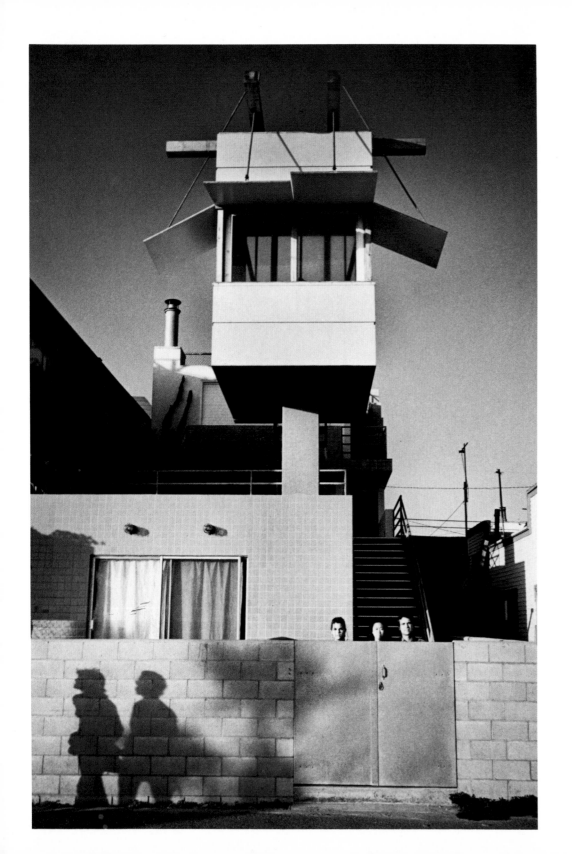

Bill, Lyn, and Nora Norton

He has directed several films, including
More American Graffiti *and* Losing It.
*His wife Lyn is a script supervisor, and his
fifteen-year-old daughter wants to be an
artist. He was a lifeguard in Venice in
1954 and says that his house is an
attempt to make something that is art.*

Barbara Brown

She's an interior designer, and the night she arrived in Venice there was an earthquake. "People were celebrating all over with parties," she recalls. She met her future husband at one of the parties.

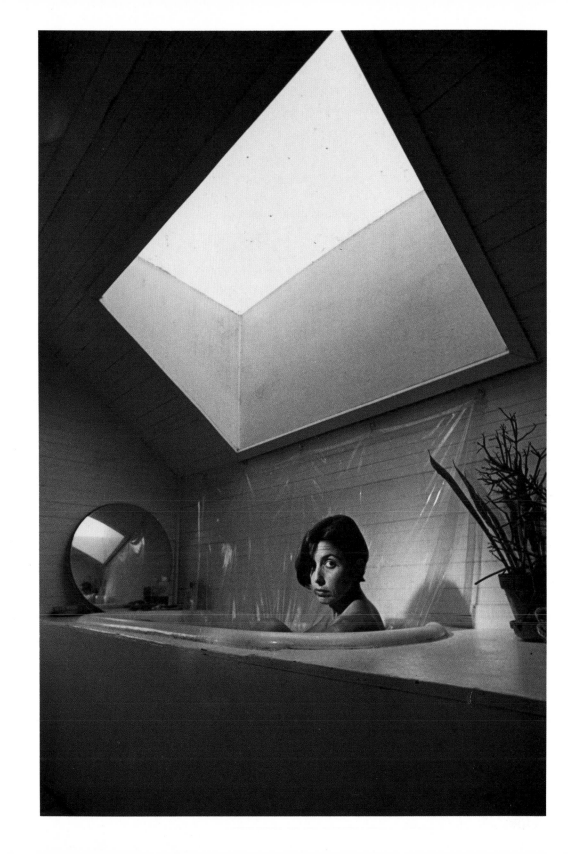

58 Rousbeh and Baktash

These two Iranian street performers call themselves "ultra-actors." Rousbeh is a hairdresser and Baktash is an aspiring cinematographer. Combining principles of breakdancing, avant-garde movement, and recorded noise in their repertoire, they make an average of $35 an hour.

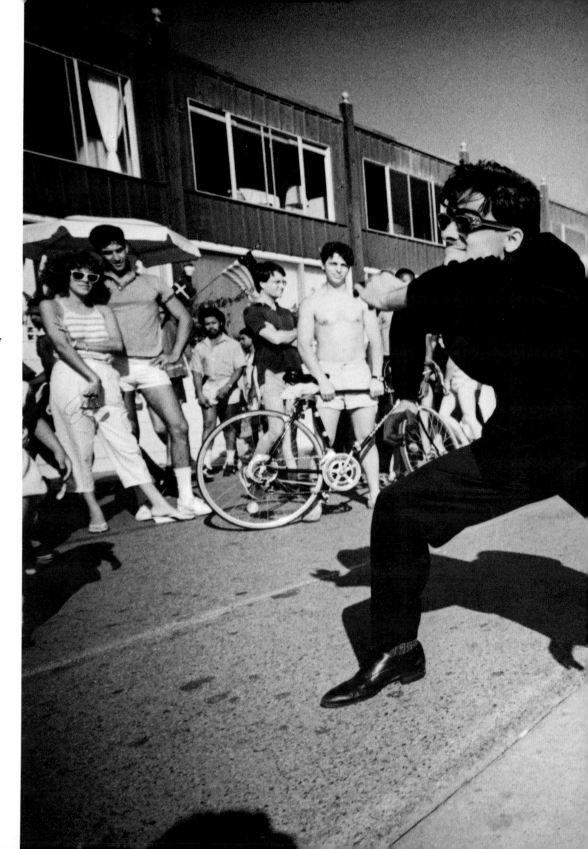

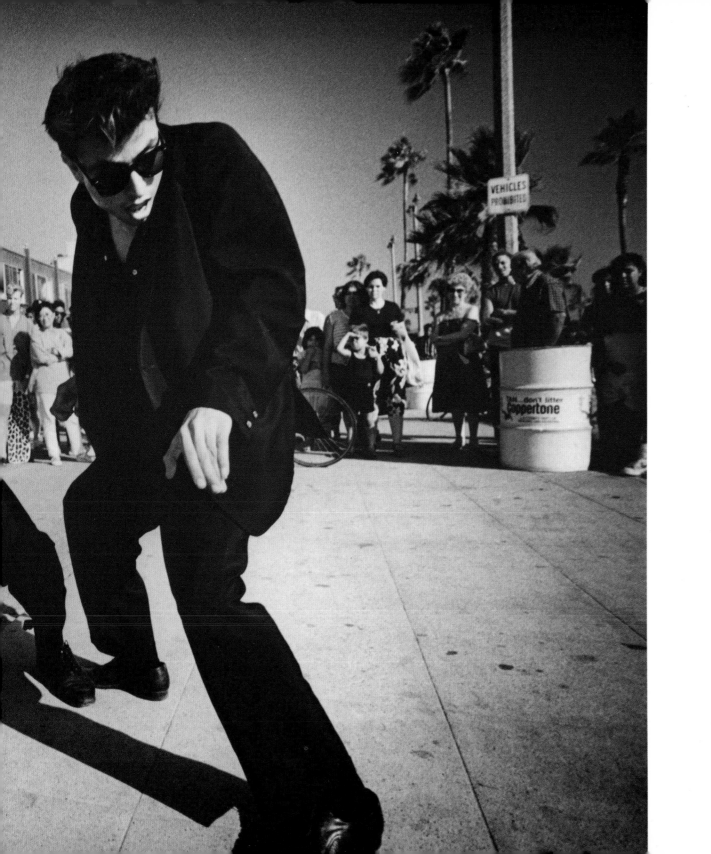

60 Linda Albertano

Her first night in Venice she discovered that
a former school chum had been strangled
on a nearby beach. She calls Venice a
"slum by the sea," but appreciates the
reduced rents. A former jazz singer, she
wrote the music for Sam Shepherd's play
The Unseen Hand. *She lives in a 13-room*
home bought with a student loan.

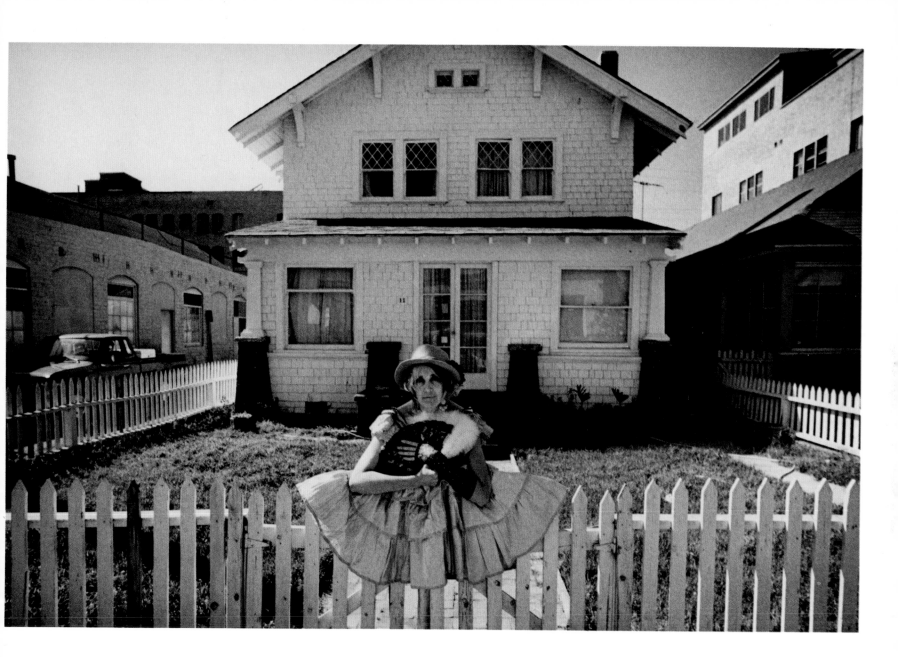

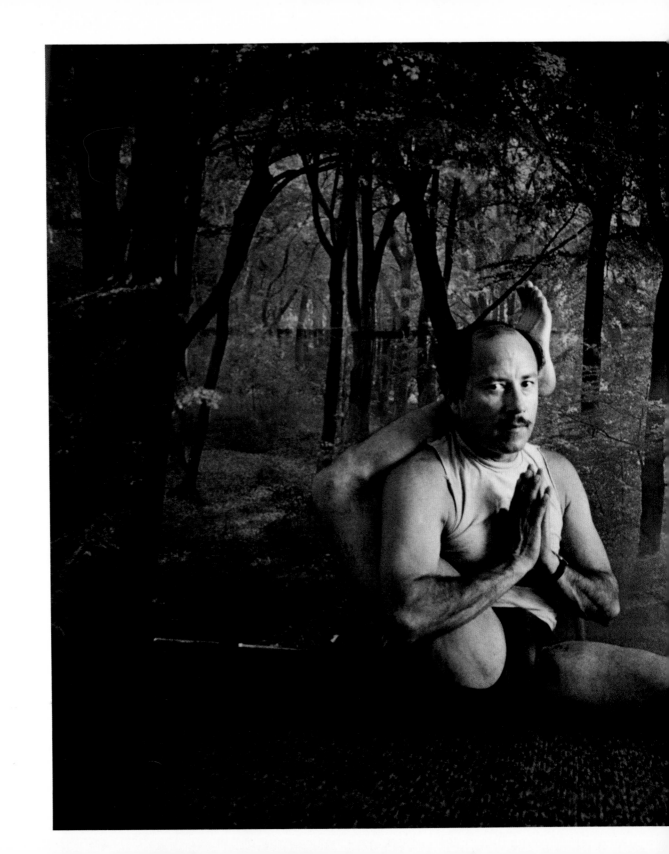

*Born in Equador, Raghavan is a Yoga
instructor and founded the Yoga Scientific
Institute.*

64 Loren Paul Caplin

A composer and playwright, Caplin says,
"There is a sense of community in Venice;
you know most of the people around. There
is interesting architecture, cafes, and
good espresso. . . . This is our little Mont-
martre."

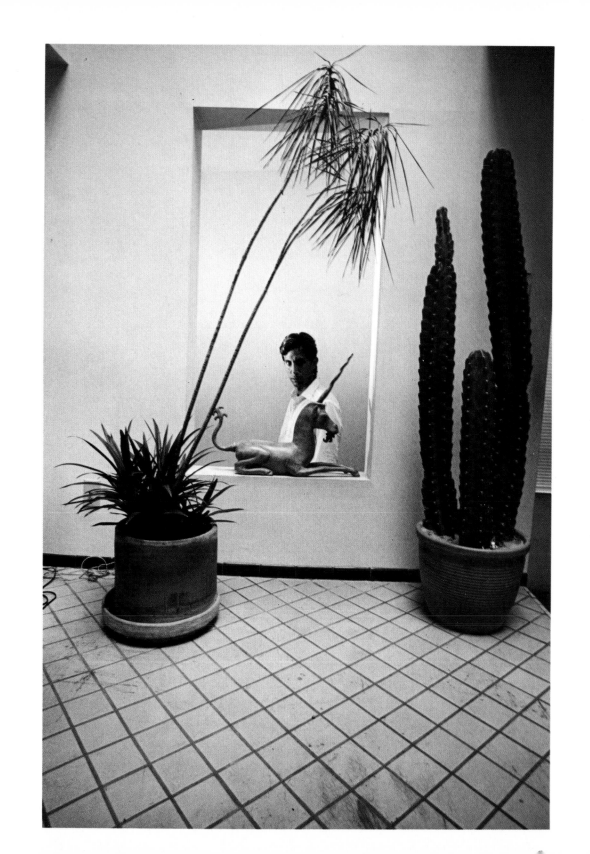

Andrew Sexton

A Michael Jackson impersonator, he dropped out of the political science program at Norfolk State University in Virginia. "Venice is an intercultural social gathering," he says. "And I as a performer have gained substantially just by being here."

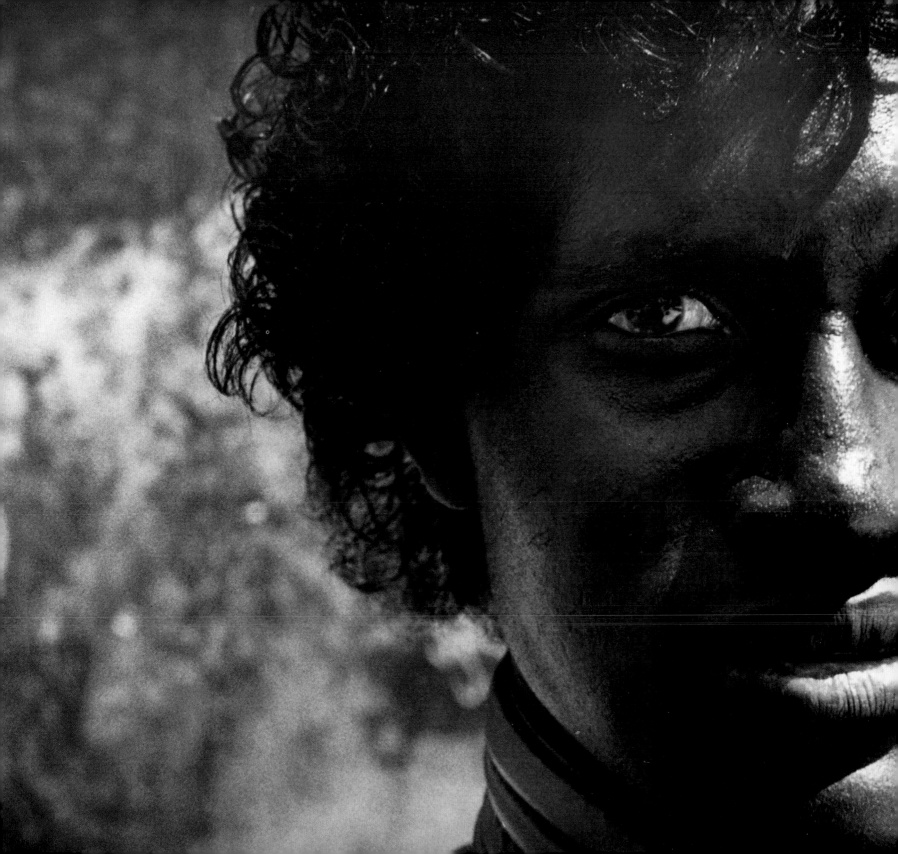

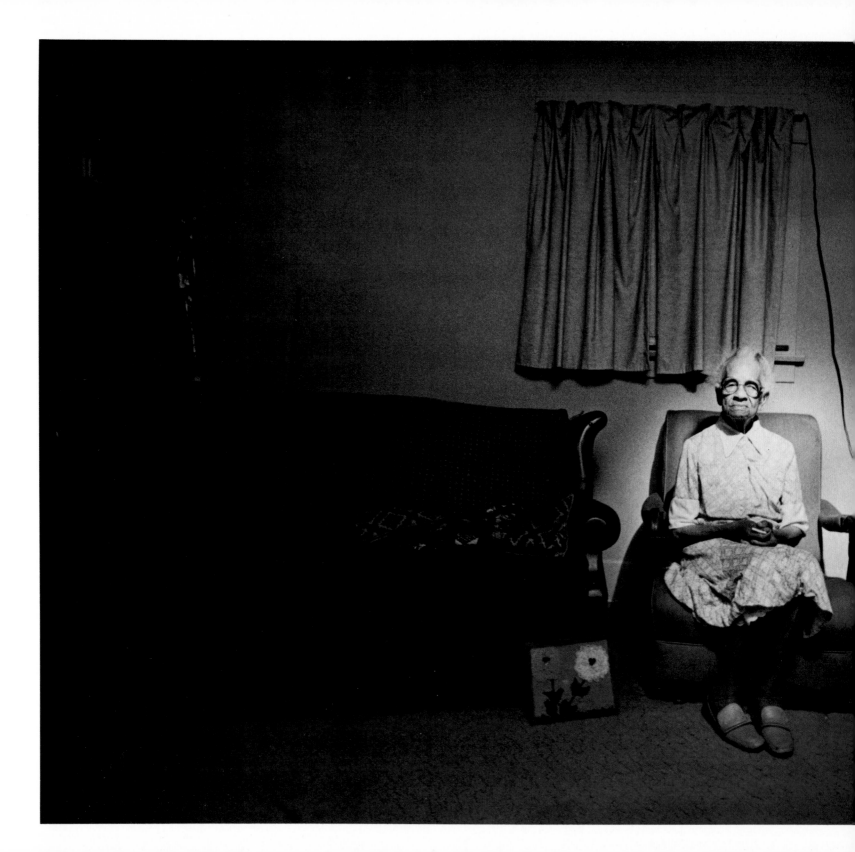

Della Elizabeth Powell

*"Venice ain't gettin' no better," according
to this ninety-five-year-old former Civil
Rights activist. "But it ain't gettin' no
worse either." She's been a resident for 40
years and helped organize a grass roots
city-preservation movement in the fifties
and sixties. She is credited with being one
who saved Venice from "Miamiization."
"Don't put your light out," she counsels.
"Let it shine wherever you are."*

70 Bruno Beine

Fifteen years ago doctors told him he was terminally ill. Unable to move, he had difficulty breathing. "But the fresh air of Venice and a change of diet saved my life," he says. Beine is also a student of numerology and has discovered that Venice is a "number four." "It changes whoever gets in contact with it," he explains. "It's changed me," he claims. He has a B.A. in Latin.

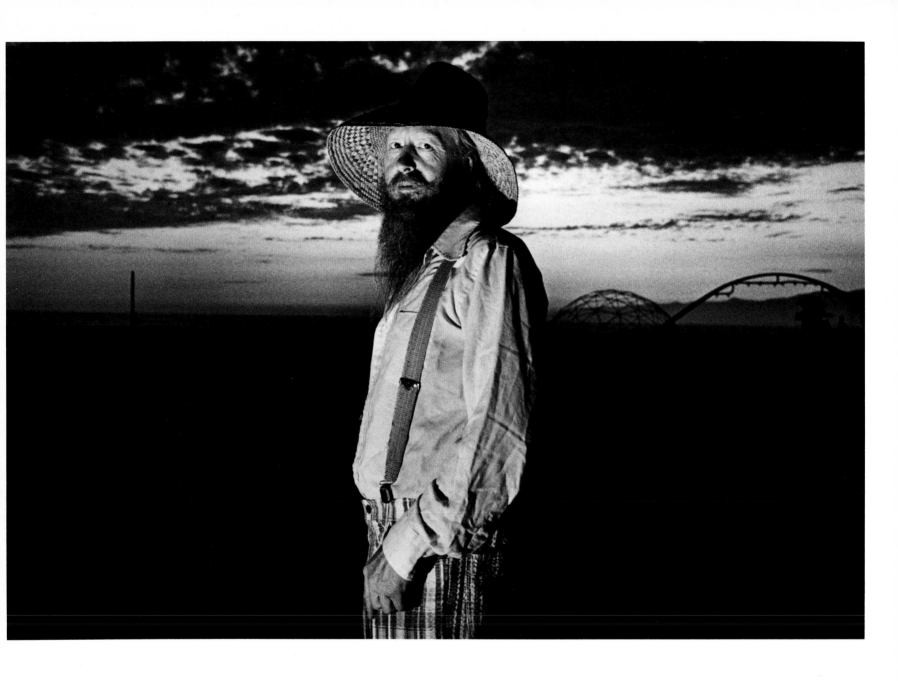

Liz Bevington a.k.a. Skateboard Mama

This grandmother is a manager of an apartment building and skateboards through the boardwalk regularly. She also participated in the Senior Citizens Olympics and won three gold medals.

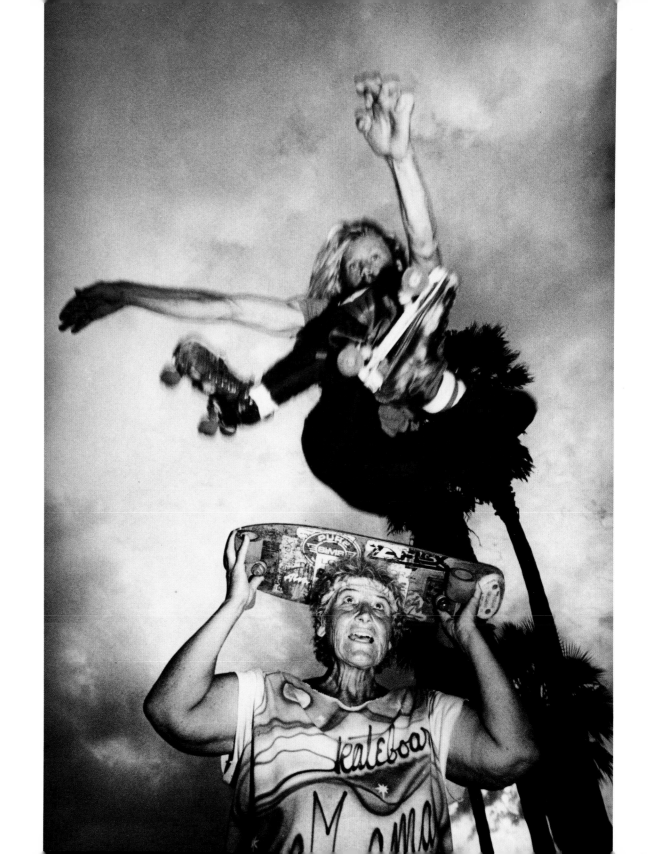

Robert Alexander

*Alexander is a poet, a former junkie, and
founder of "The Temple of Man." He came
to Venice almost 50 years ago as a run-
away ten-year-old kid to work as a barker.
"My life is very strange," he declares.
"Everything comes to me in visions."*

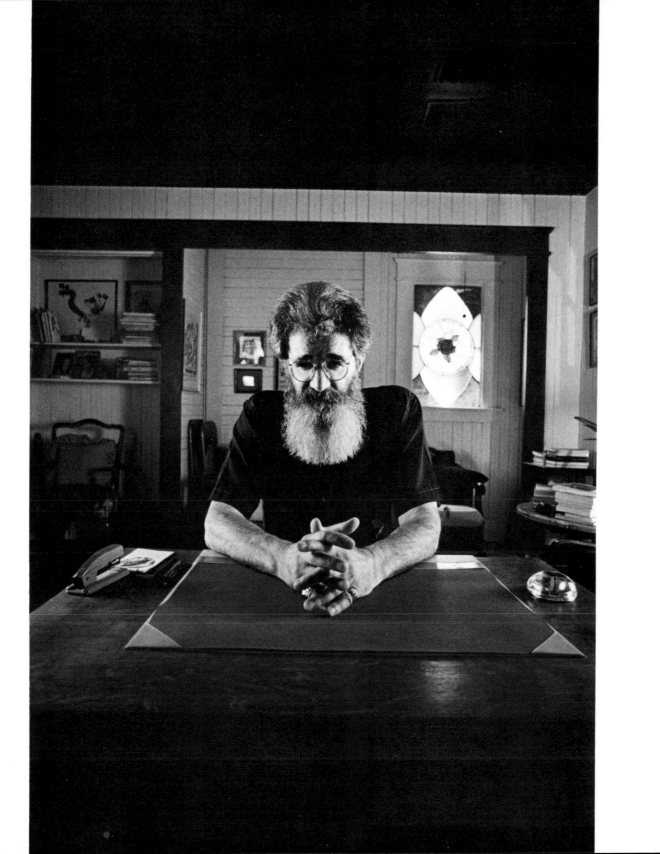

76 Eliot Rosen

A Sikh, Rosen admits that his parents are not happy with his life-style. "They wish I'd drop this Eastern Guru thing and become a nice Jewish boy again. I told them 'don't hold your breath, folks.'" He prepares raw food meals for cancer patients, writes for health-oriented magazines, and plays the drums for a belly dancer.

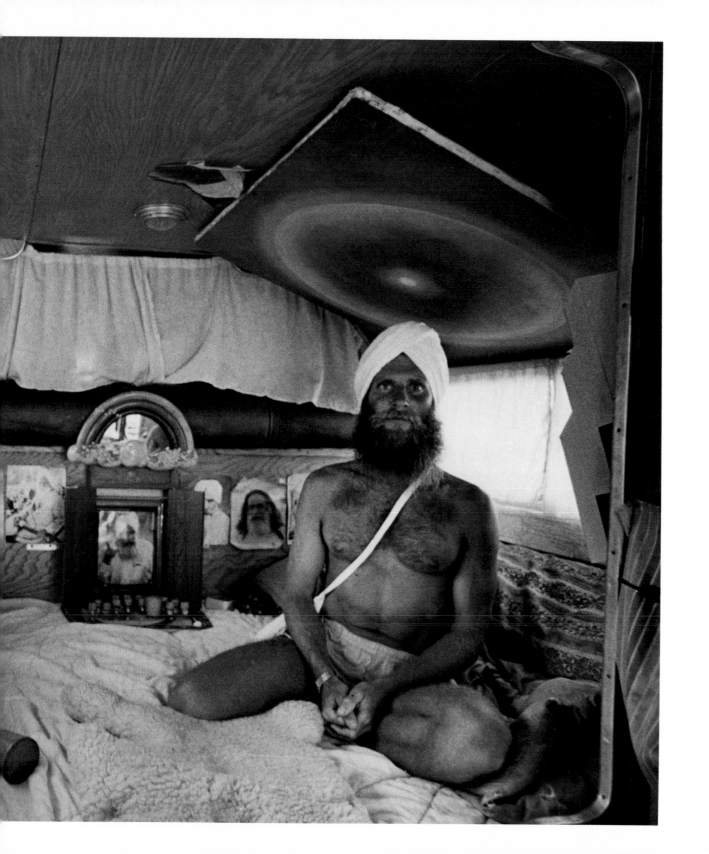

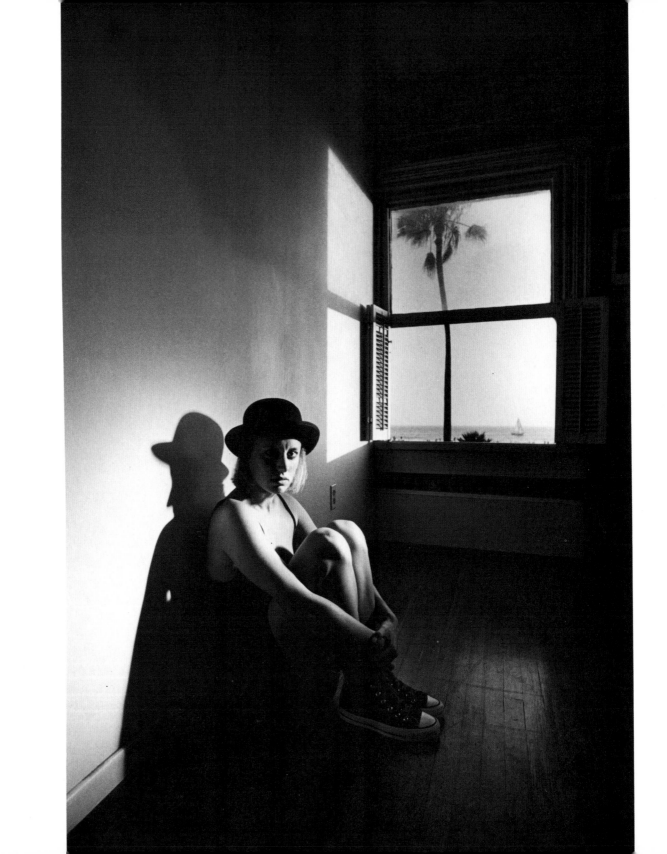

Alison Price

Alison came to Los Angeles from New York to appear in the movie Grease II. *She settled in Venice even though she doesn't feel safe. "Sometimes after I park my car, I take off my shoes and run home," she confides. "Still I'm inspired here; I don't feel isolated."*

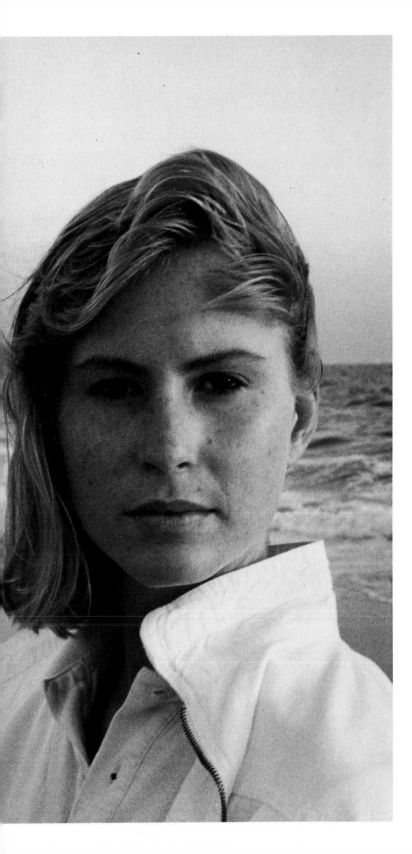

Shannon and Sharon Allred

These twin sisters after selling tee shirts on the boardwalk decided to become fashion designers. "We want to make a lot of money and travel around the world," they say. Shannon is a secretary and Sharon has just left her job.

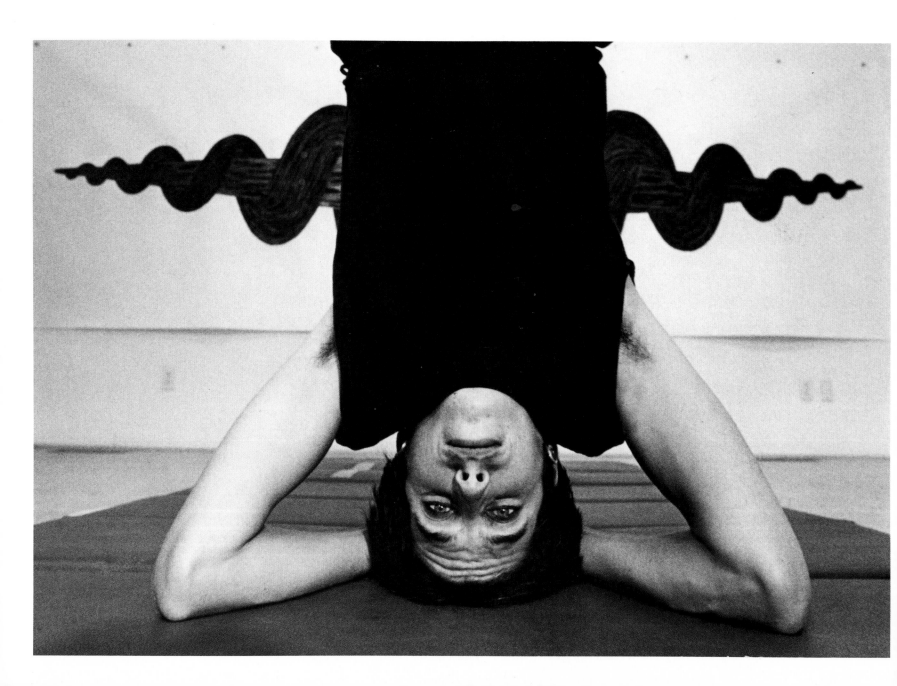

This painter says that if you turn the United States upside down, everything that is loose will fall into Venice. "Venice is very moody," she adds. "Sometimes it is very quiet, sometimes very violent." The first place she moved into in Venice was a warehouse and it came with a baseball bat—for protection.

Peter Alexander

"Venice is now an expensive slum," says
this painter and fine arts graduate of
UCLA. A former NEA grant recipient and
Guggenheim fellow, he has had shows at
the Whitney and La Jolla museums and at
the Museum of Modern Art. He's been
painting sunsets for the last ten years, and
he also paints velvet squids underwater.

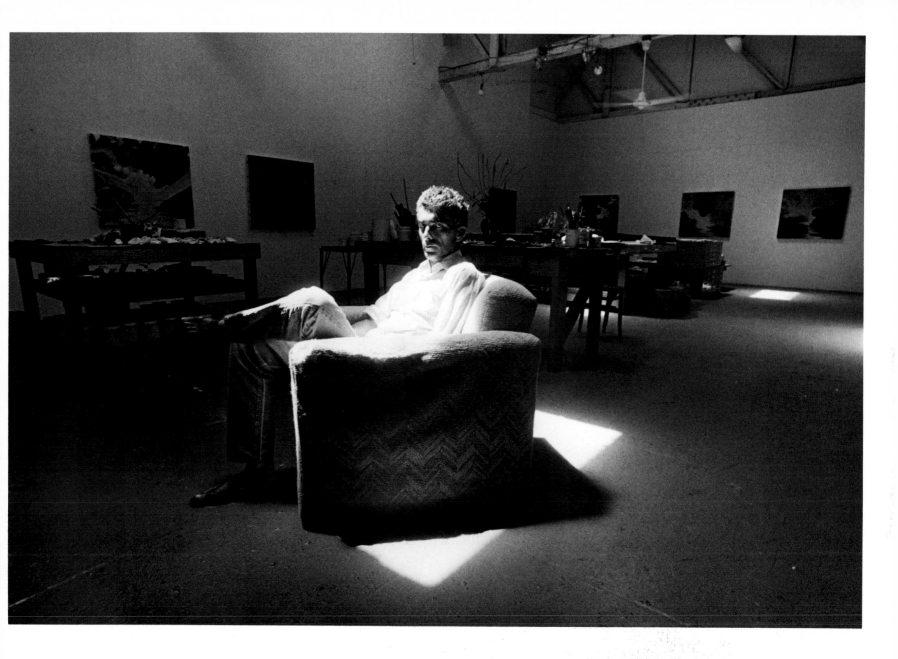

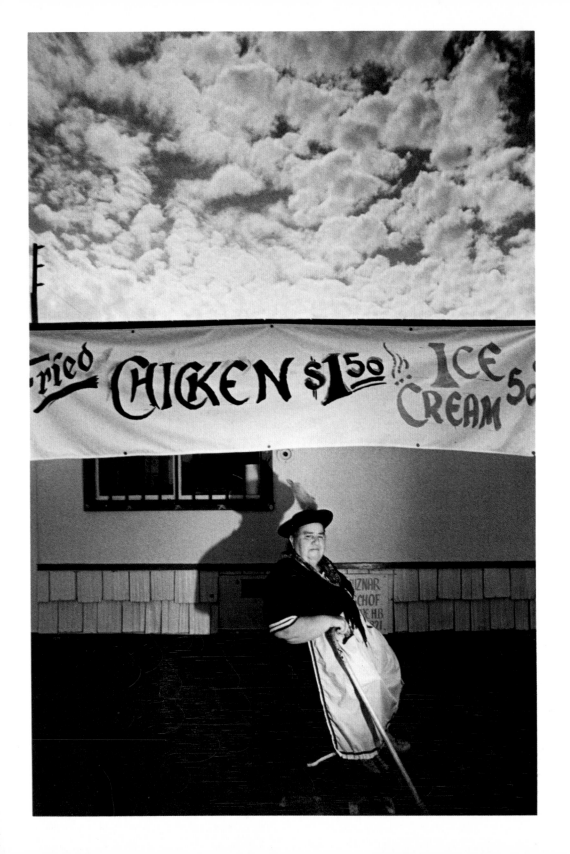

Maria Ilg

This sixty-eight-year-old, German-born former pretzel saleswoman sits in front of this fried chicken truck trying to attract customers. "Venice is so dirty," she complains, "you can't even go to the public bathroom." After a pause, she admits, "It's a great place to sell fried chicken, though."

Joe Joesting

He operates blue print machines for the telephone company. "But I would like to study Japanese and get into fashion," he says. He thinks of himself as androgynous and says that Venice is known as "dog town, because of the stray dogs and the ugly girls chasing after the surfers."

Ronald Benjamin

*He claims that his "blaster" is the biggest
on the boardwalk. "Girls love it," he says.
"It takes ten batteries and weighs 30
pounds." He's an auto-body repairman,
part-time photographer, and wants to be a
computer programmer.*

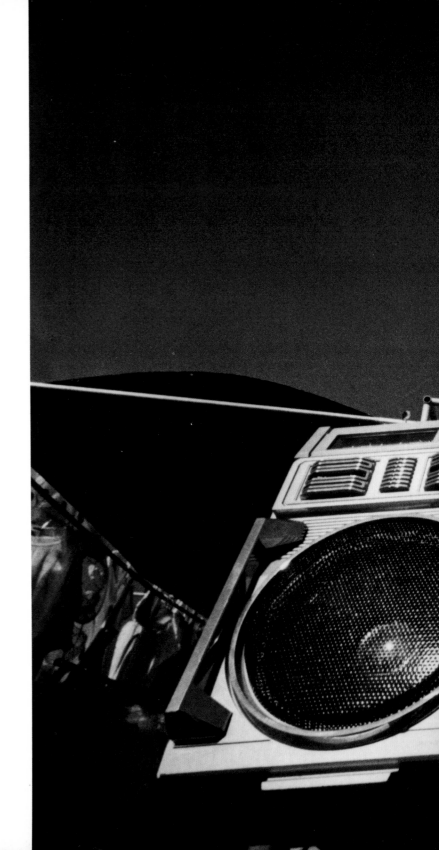

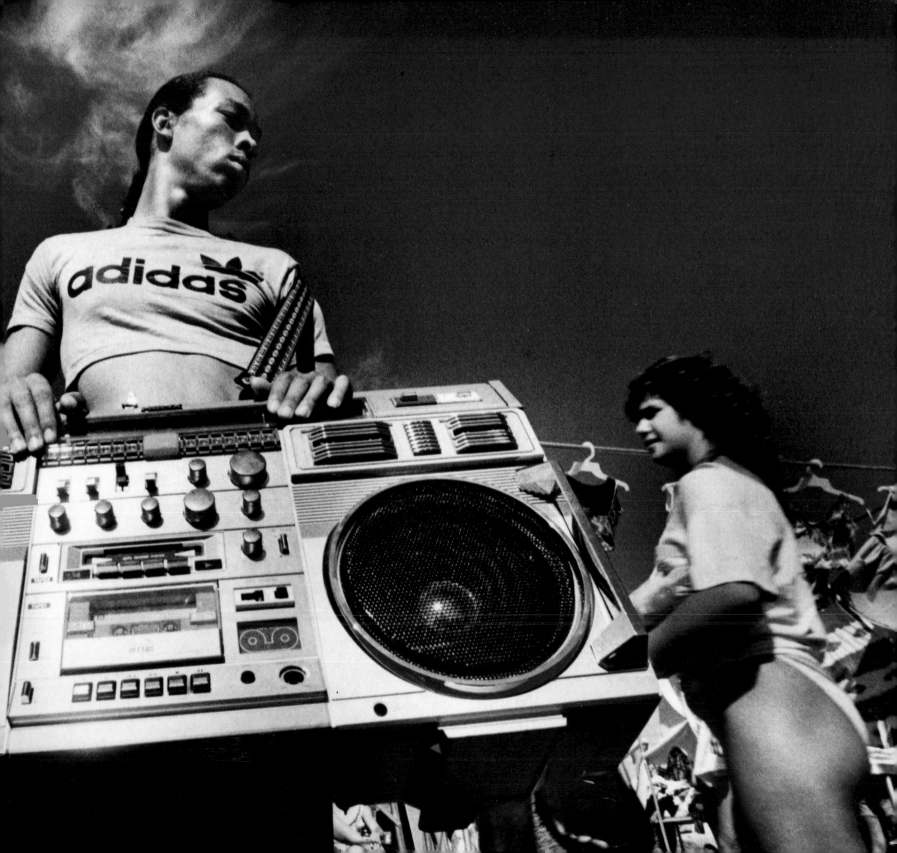

90 Gary Jacoby

He plays the drums for "Vagina Dentata,"
a rock band. "I am threatened every day
because of the way I look," he says. "Macho
jocks scream and yell, and laugh at me
all the time, but I don't mind. I like to look
ridiculous. When we play the clubs, we
look absurd. People want to beat us up;
they have no sense of humor." He describes
his ideal woman as a schizophrenic, with
six different personalities and appearances.
"I'm not very demanding," he explains.

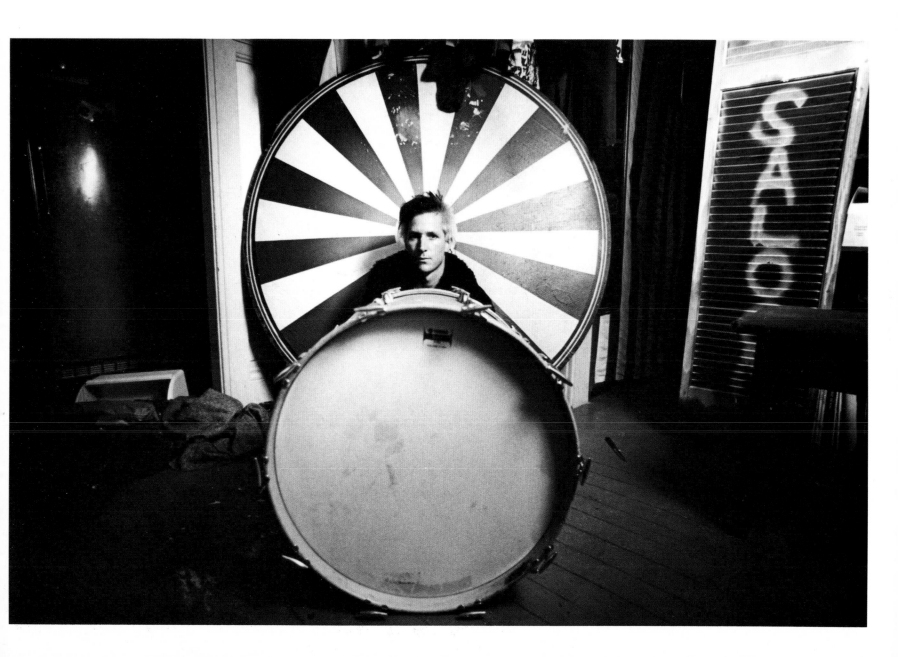

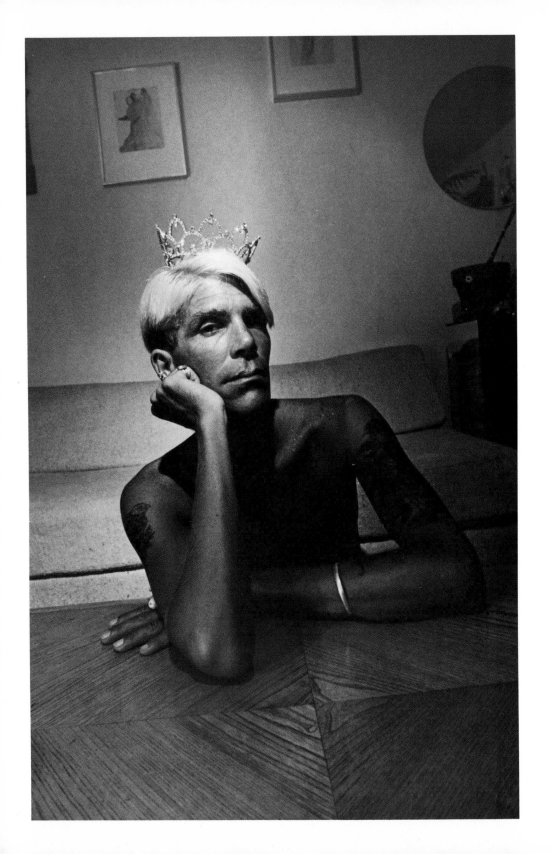

Goldie Glitters

Goldie says, "I'm a male actress." When he was seven, he fell in love with an eighteen-year-old boy. Now at thirty-eight, he claims to have had 10,000 men. In 1981, he was elected "Queen of Venice Beach."

Martine Vaugel and Joe Miller

*"The abstract evaluation of forms and
decisions therein are my favorite form of
play," Martine declares. Her sculptures are
in the collections of the Rockefeller family
and of the Museum of Contemporary Art in
Los Angeles. Joe is a former liquor sales-
man who earns a living by nude modeling.
He has a history degree from the Univer-
sity of Minnesota.*

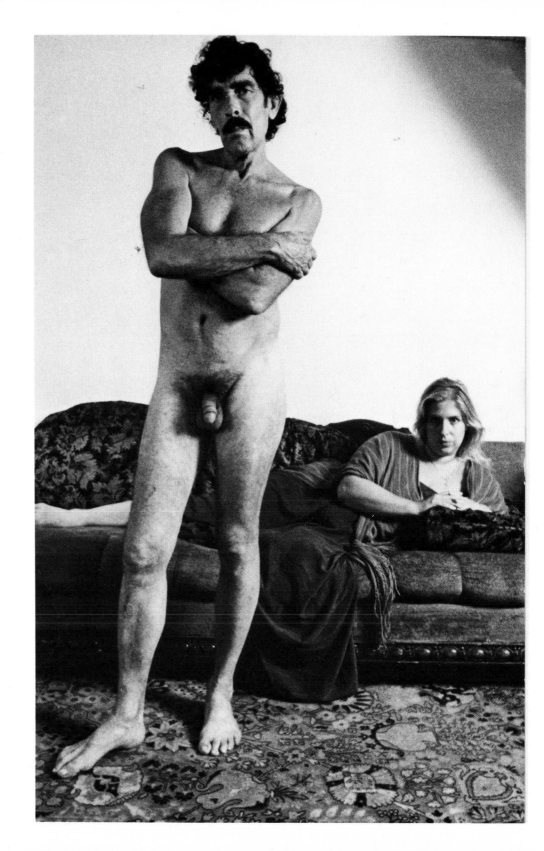

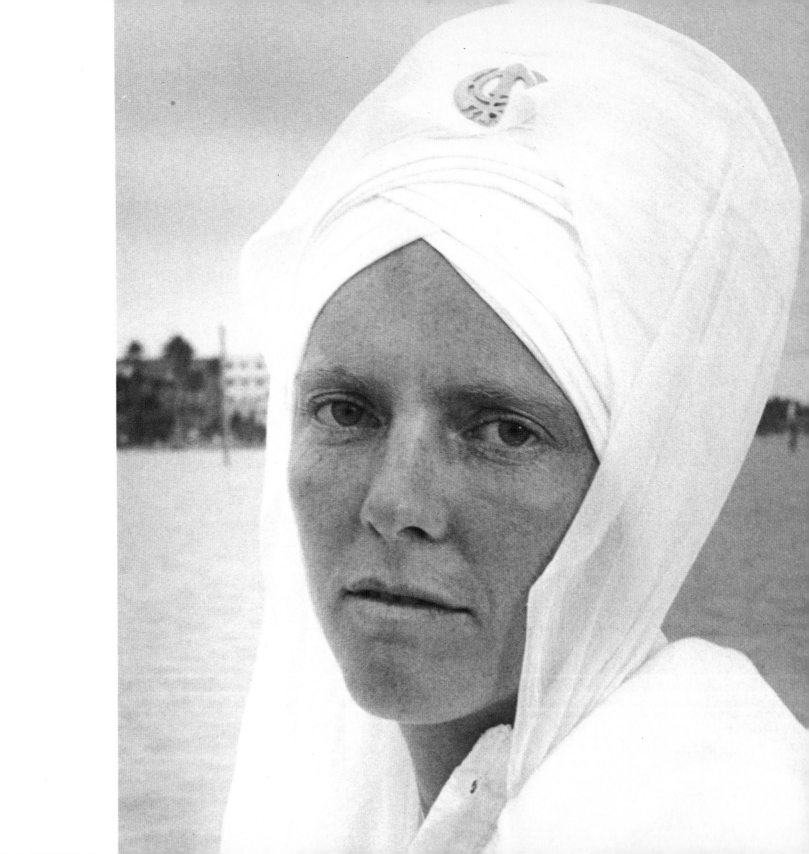

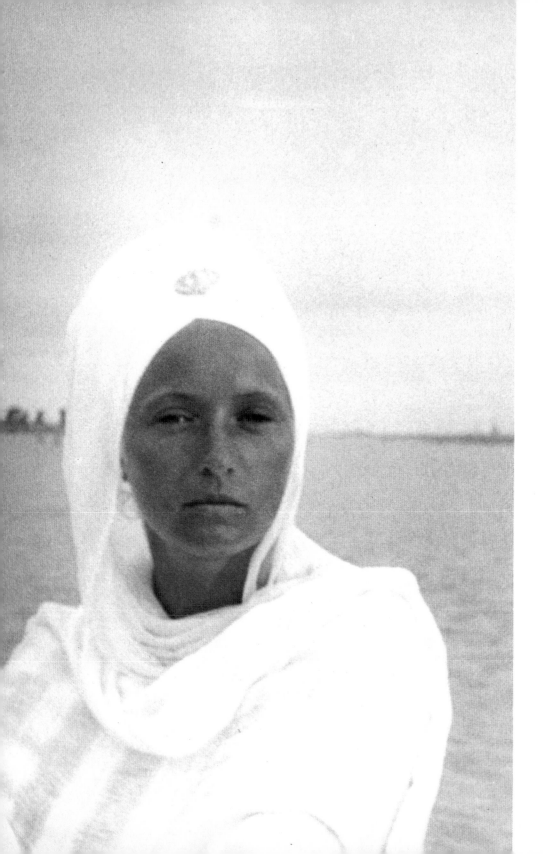

Hari Simran Kaur and Atma Kaur

Hari's parents are Trotskyists. "I'm a merger between spirituality and the old left," she says. She founded the healers movement in Venice. Both she and Atma are Sikhs. "It's the most radical religion," Hari says. "It's the toughest discipline in town."

De Wain Valentine

He and his wife, three kids, cat, and Saint Bernard came to Venice in 1965 and lived in a garage. "The quality of light and the air here have had a pervasive influence on my work," he affirms.

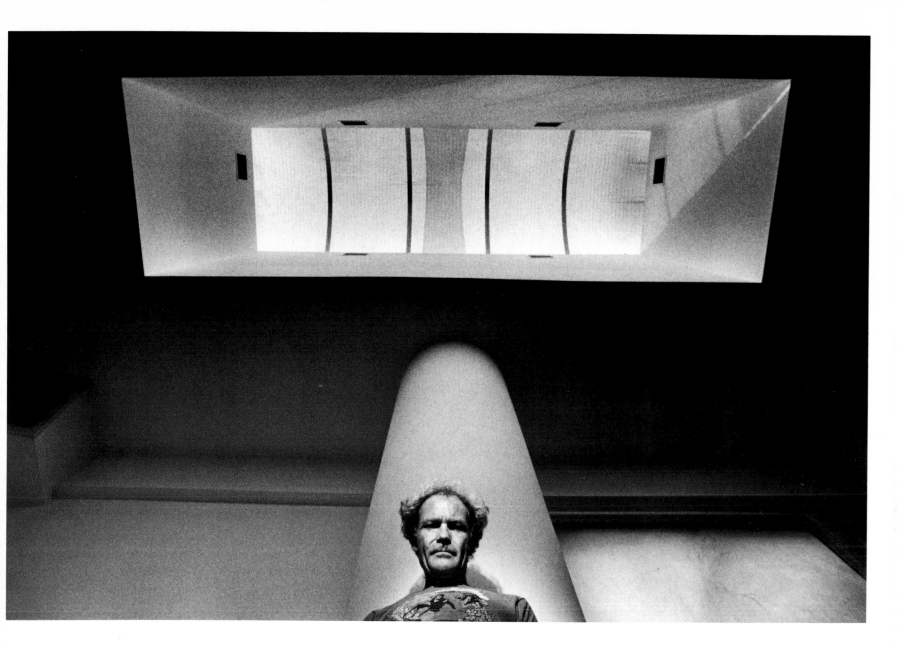

Rick Petty

He's a vocational nurse but works in a pet shop. He shares his house with a menagerie of parrots, snakes, baby alligators, dogs, piranhas, and turtles. His seven sisters won't visit him.

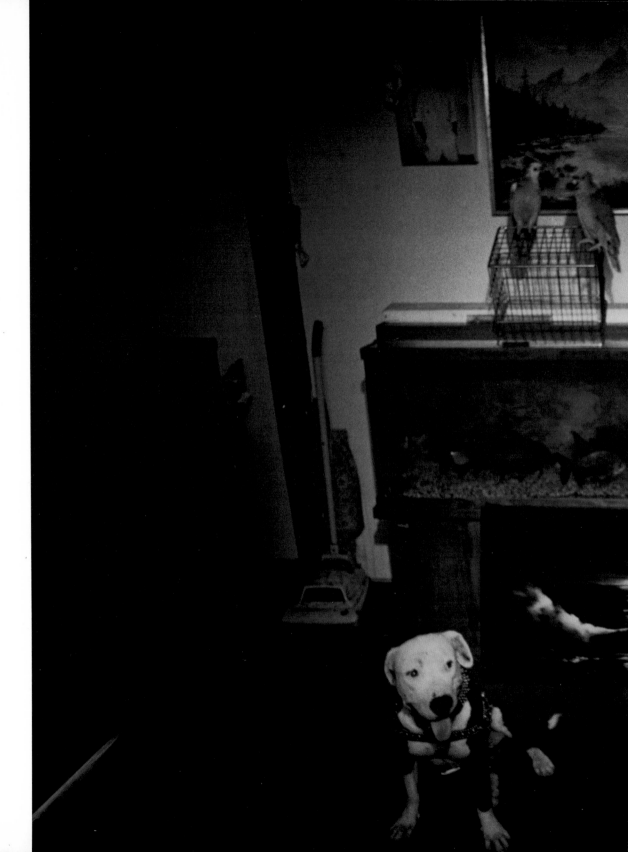

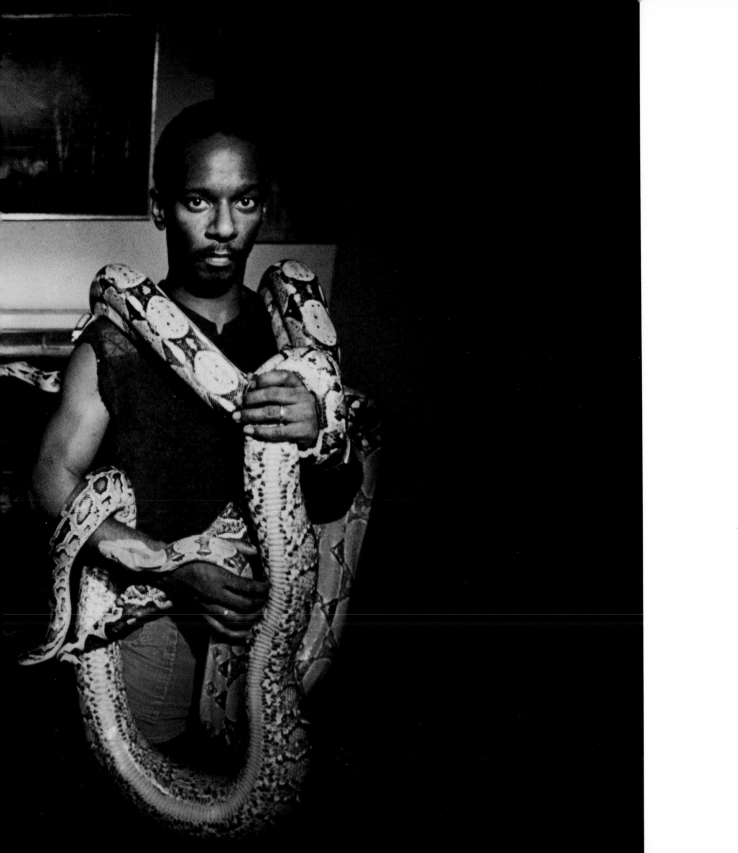

"In 1977 the first rollerskates store opened in Venice, and with polyurethane wheels the skaters multiplied all over the board-walk—Venice became the rollerskating capital of America."—Los Angeles Times

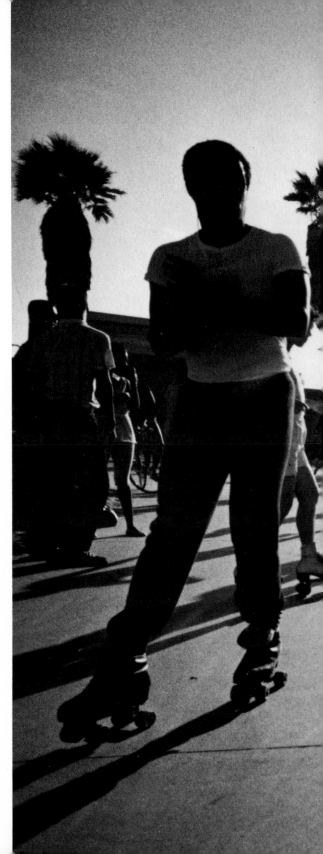

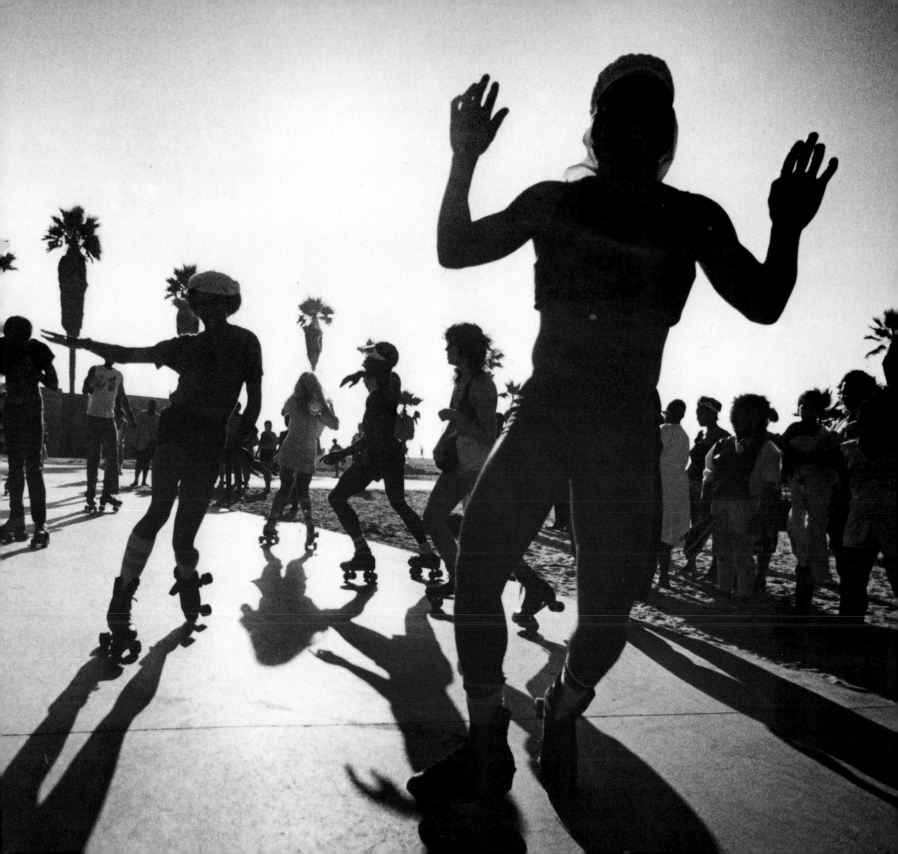

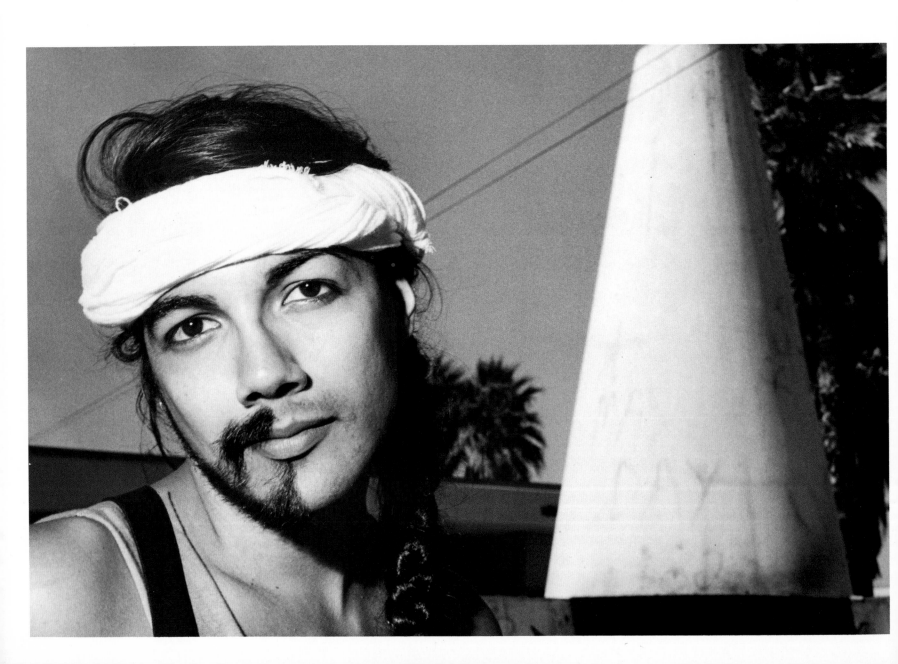

Luis Hansa

"My androgynous look is my art form," he says. "When I'm out in the streets, it's like being in a performance." He's a free-lance custom designer from New Orleans.

Jennifer Maurer and Nickie Black

Jennifer was born the year Marilyn Monroe died and feels an eerie attunement to the late actress. "Like her, I want to succeed by myself, and I enjoy having many different personalities," she explains. Nickie's mother was a heroin addict and he never met his father. They'd like to start a rock band named the Venetian Blinds. "Our motto would be 'All Else is Curtains.'"

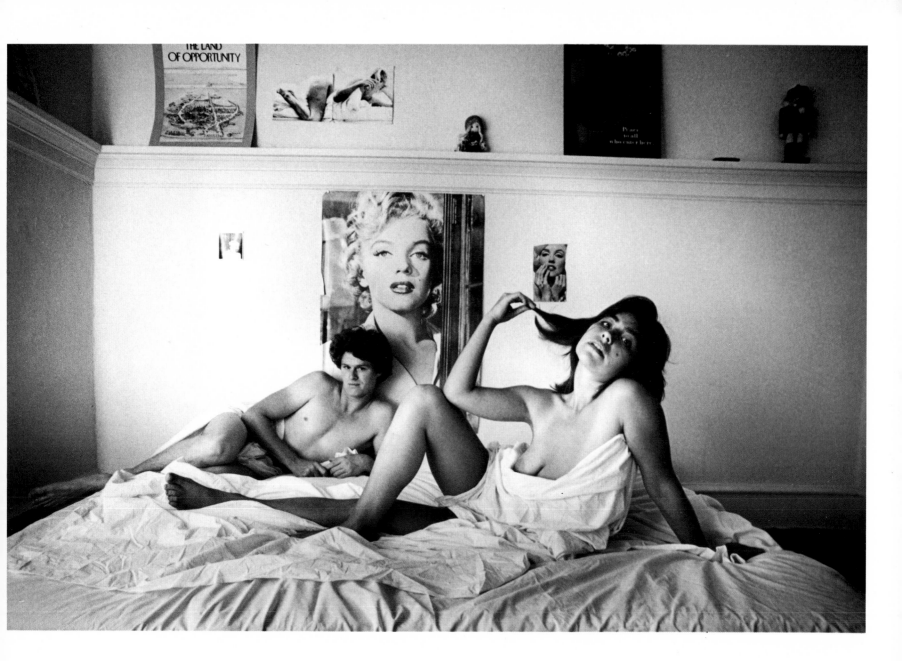

106 Shelie Scott

Born in Hawaii, she designs women's blouses. She loves to go swimming at night and dreams of starting her own glue factory. "It's a great product," she says. "It helps to stick things together."

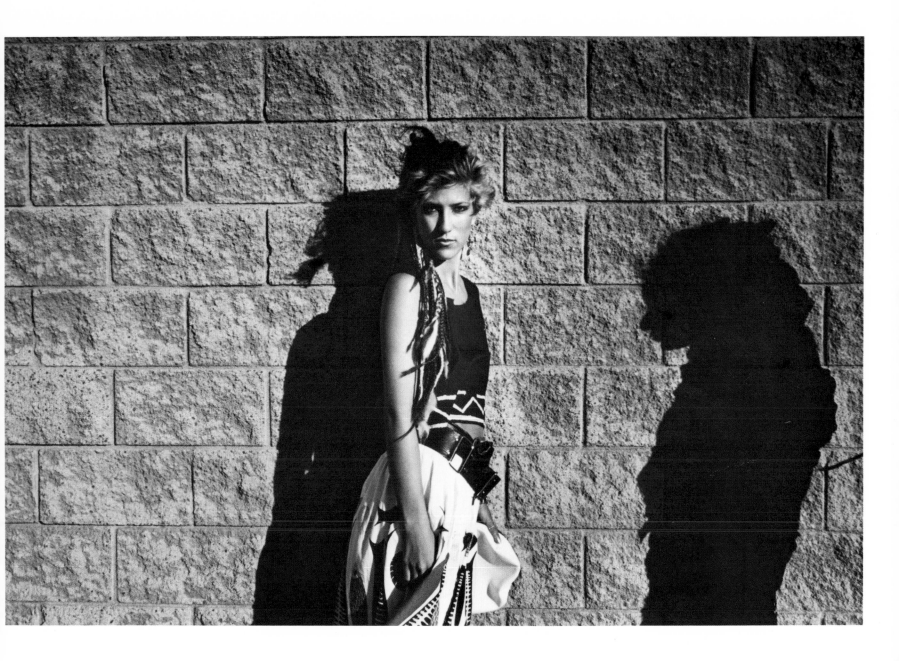

108 Greg Reid

*"I come to Venice to show myself off," says
this twenty-one-year-old Marine. He plans
to compete professionally as a body builder
and trains five to six hours every day.
Asked if people provoke him into fights,
Greg says, "Nope. Besides, I'm a pretty
mellowed-out dude."*

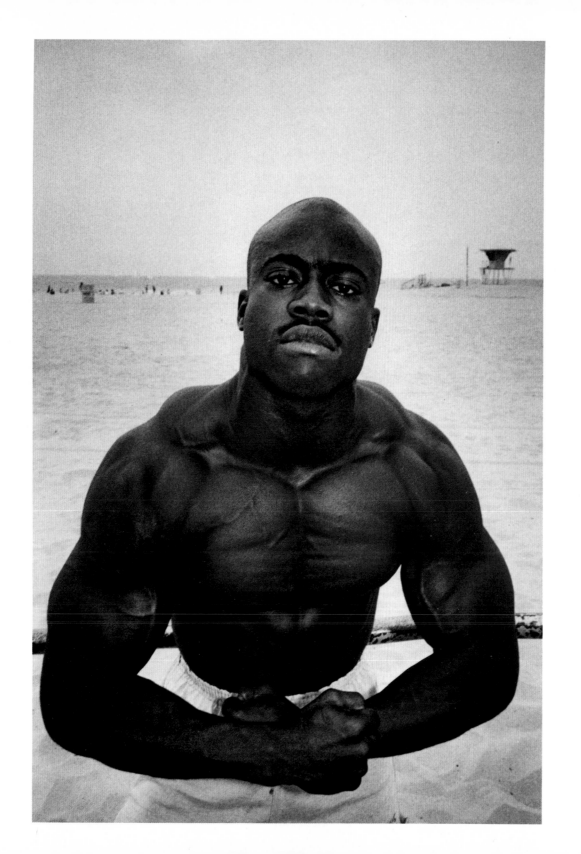

George Herms

He wants to go from "adolescence to senility, skipping all the maturity in between." As a stage artist, he plays piano, venetian blinds, and garden hose ("It sounds like an elephant."). As part of his act, he also wrestles a motor scooter. Once he nearly asphyxiated his audience by operating a diesel leaf-blower on stage.

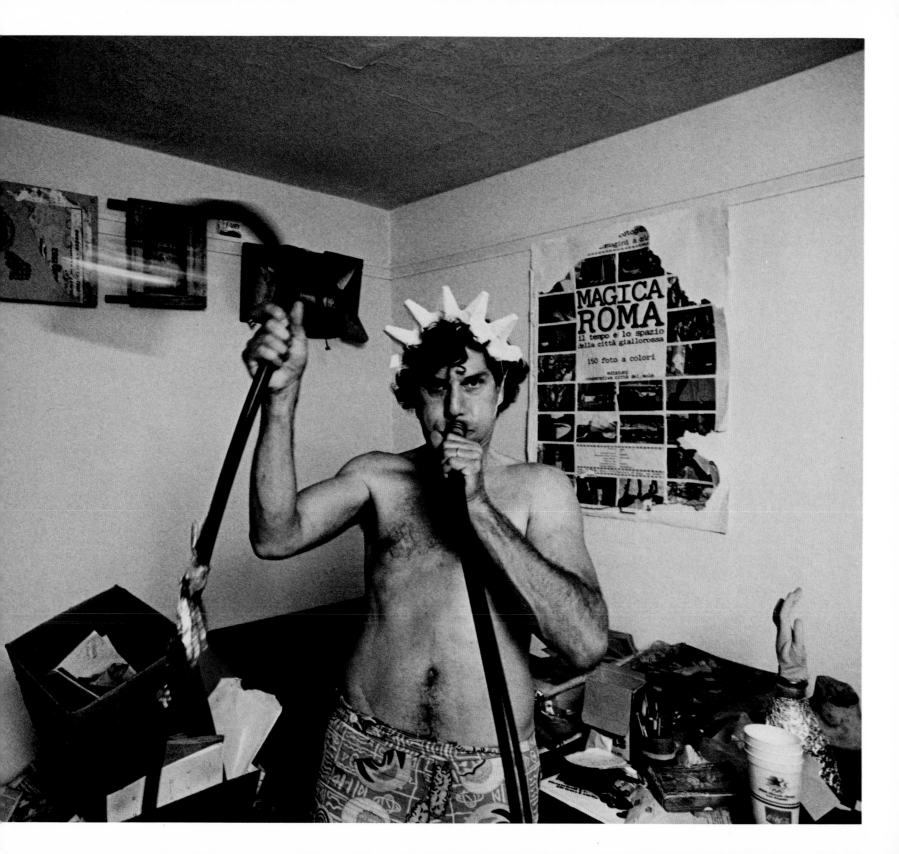

Richard Egizi

A composer, arranger, and conductor, Richard decided to form his own jazz and blues record label. "I'd been addicted to alcohol and drugs for 30 years," he remarks, "but after moving to Venice I kicked the habit." About his records he says, "I don't want hits, I want quality. It shouldn't be like selling shoes."

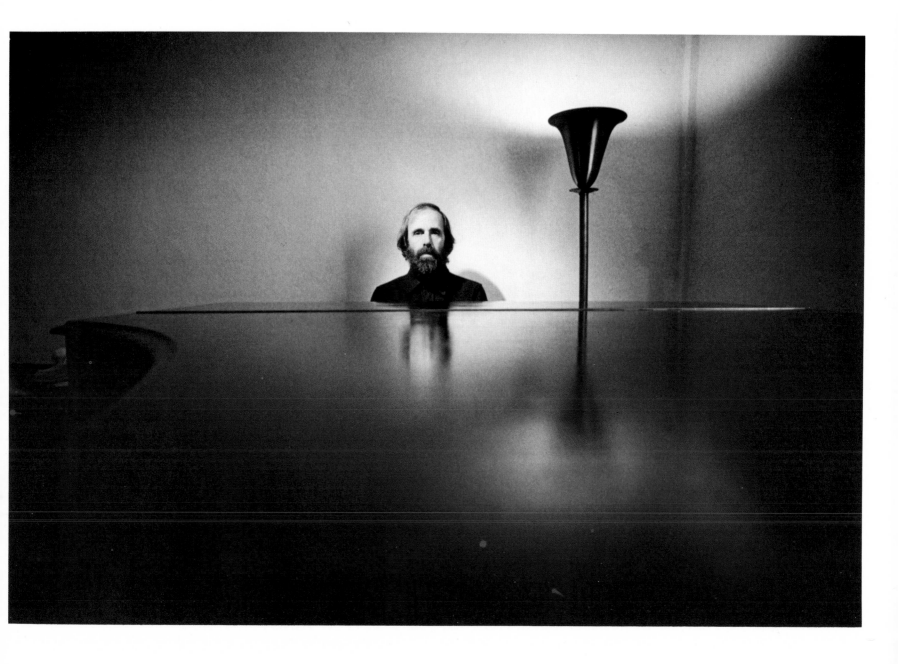

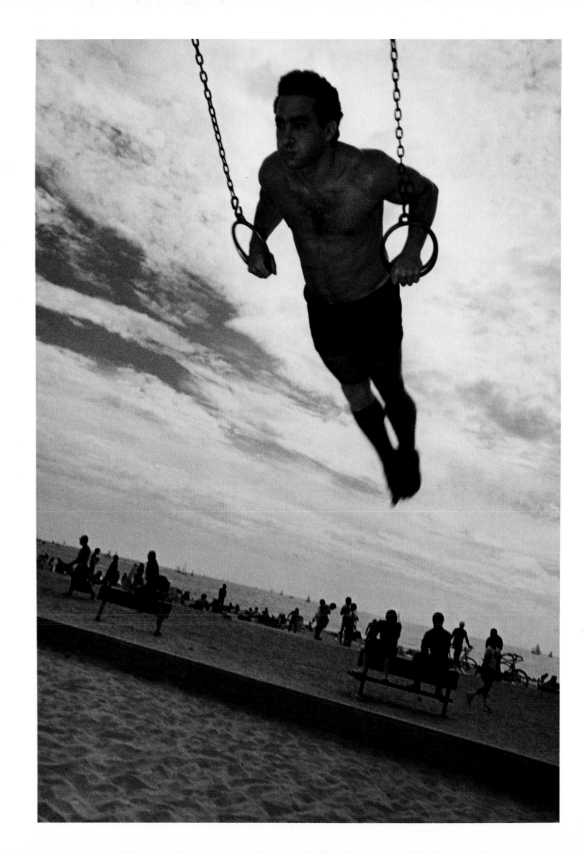

Muscle Beach

"Most of all, Venice's acceptance-of-all philosophy helps all types stop pretending to be someone else and to begin being themselves." Sweet William, *author of* Venice of America.

Kay Baxter

She was voted the best Woman Body Builder in the World from 1979 through 1983. "I want to remain young forever," she says. Her motto is, "If you don't use it you lose it."

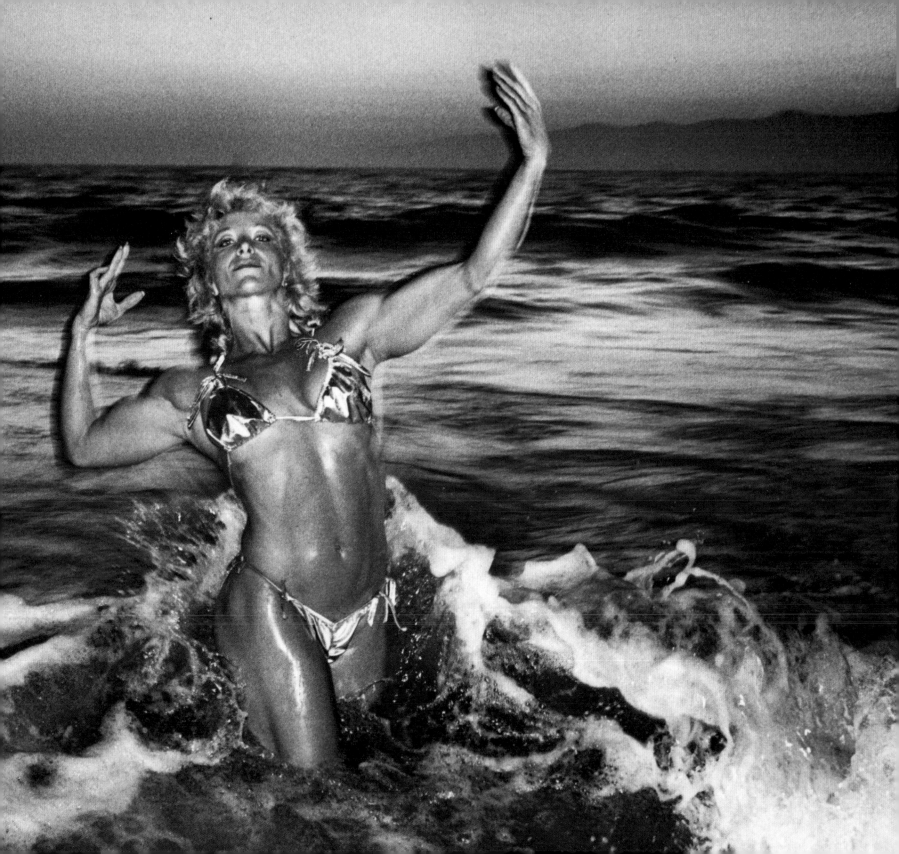

Midnight P. Dolan

He is a road manager for a rock band; before that he was a road manager for pool players. It has taken 55 hours to have his tattoo completed, at a cost of $60 an hour. "When I am gone," he says, "I want my kid to use my skin for a lamp shade."

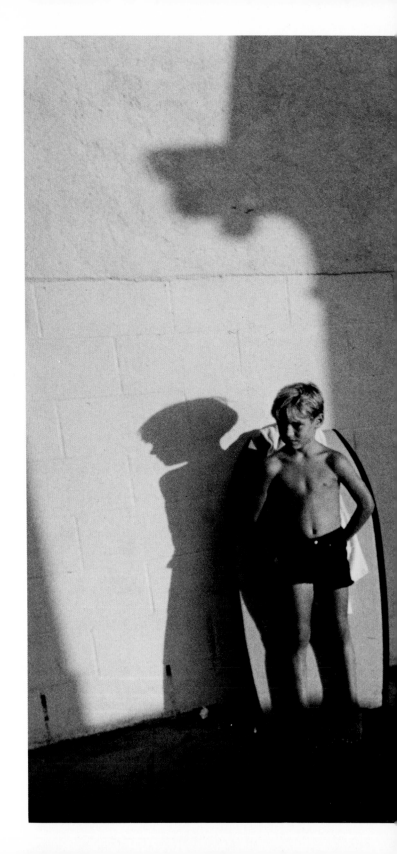

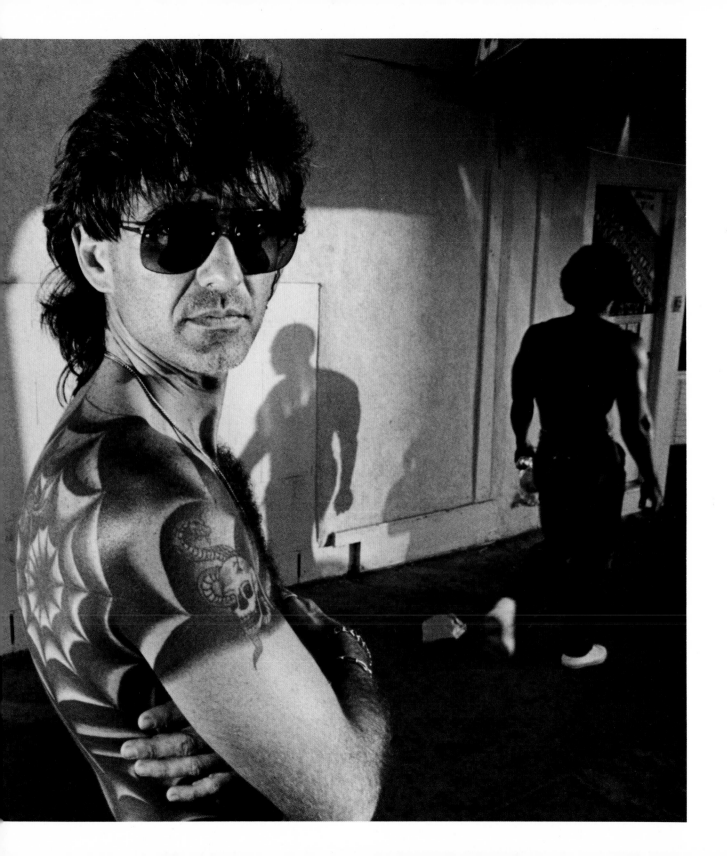

Kenny Johnson

A mechanic, he says he likes to come to Venice because of the girls. "I come to watch the bodies; I love to work on bodies." It took him over eight months to refurbish his '61 Chevy. "With this car," he claims, "I get new girls every week."

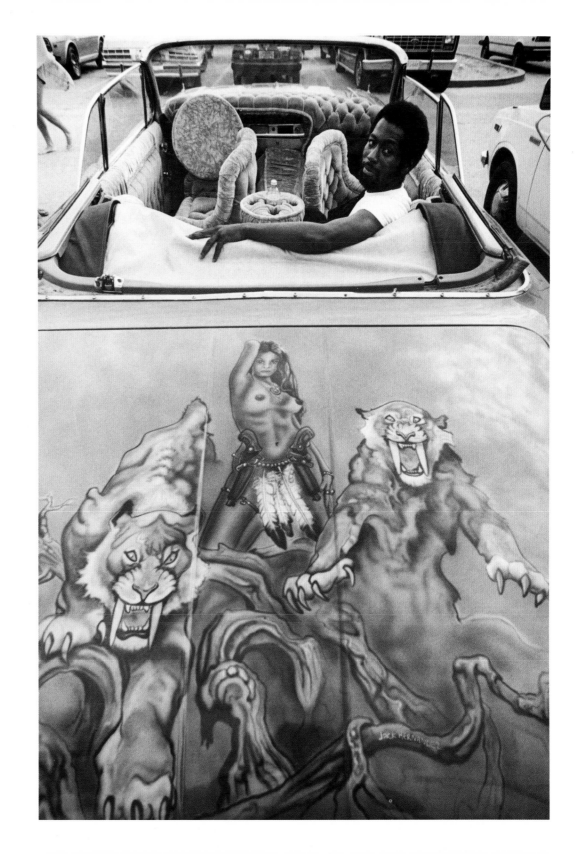

122 Side street in Venice Beach

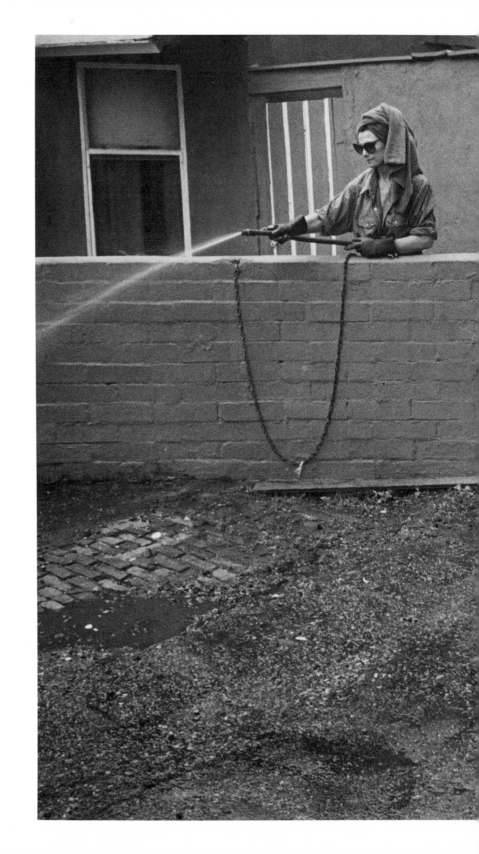

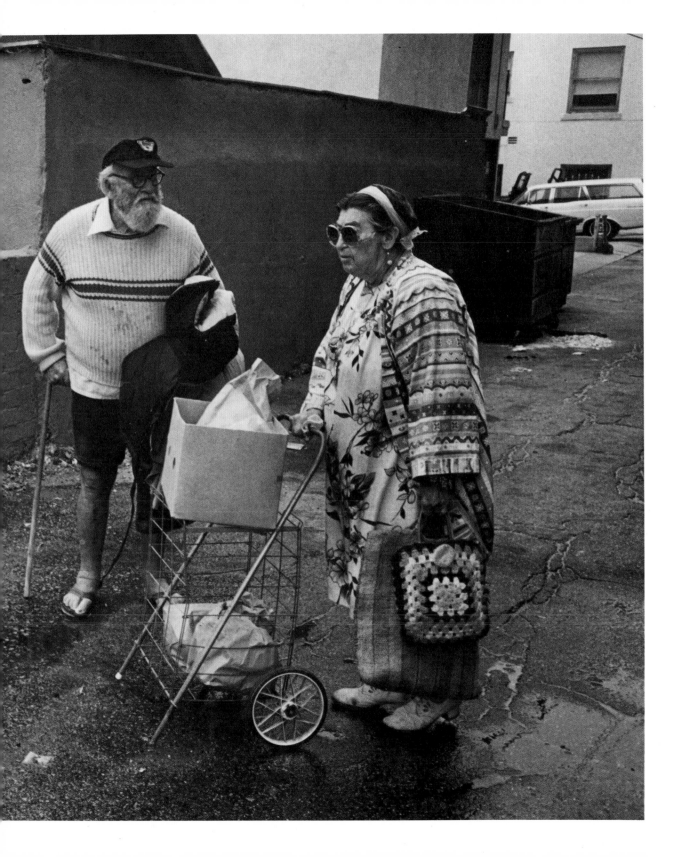

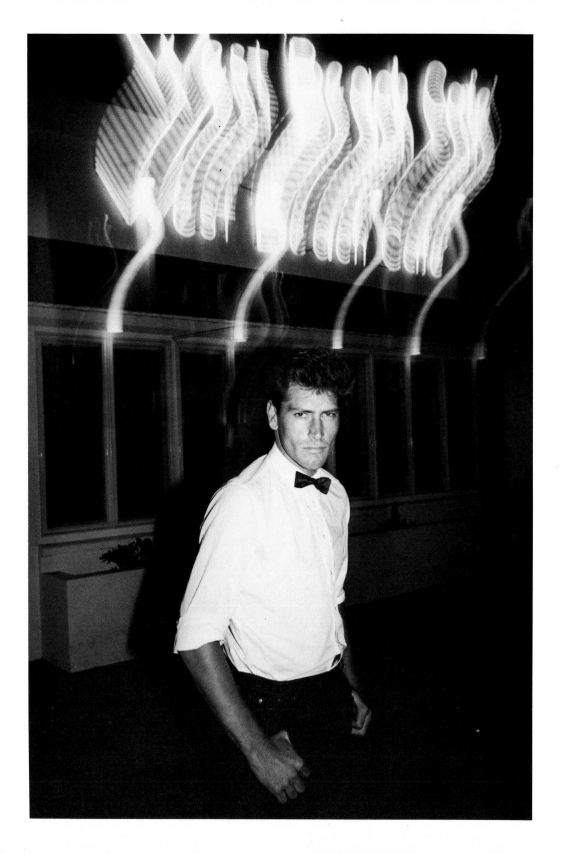

Derek Scott

Scott, at twenty-two, dreams of being an actor. "I see myself between Clint Eastwood and James Dean," he says. Meanwhile he is a valet at Venice's West Beach Cafe, a favorite watering hole for the community's artists. "This is a great place to meet directors and producers," Scott says. He'll do anything to be in a play, but he feels he may be too exotic. "I am not good for the American market."

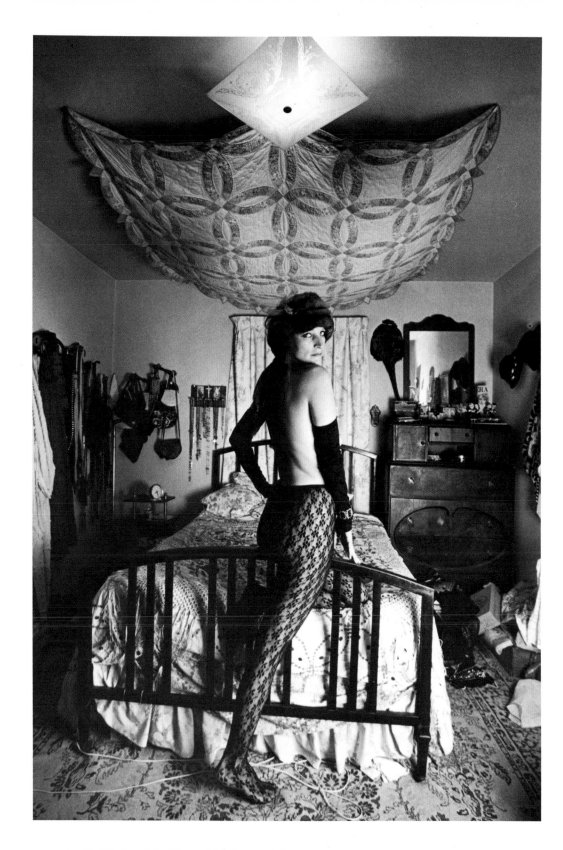

Brenda Star

A former stripper in Japan, Alaska, and Idaho, she once saved a neighbor from being raped. "I opened the window and screamed, 'I've got the cops on the phone,'" she recalls. She's now planning to go into word processing.

126 Westminster Beach

"Where the boys meet the boys and the girls meet the girls," according to a lifeguard who also does video tapes for bar mitzvas.

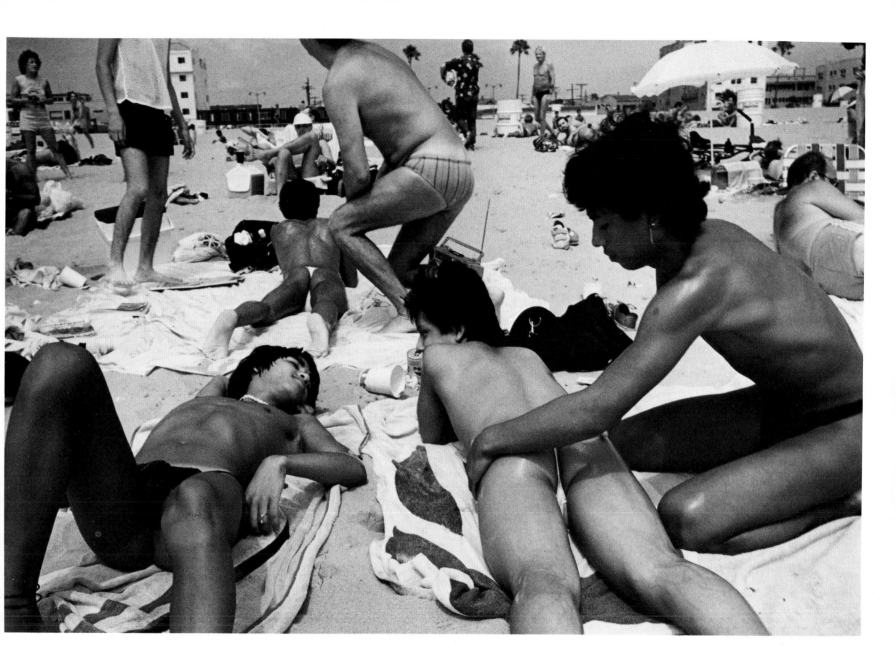

Julie Anna Smith

She started making masks one Halloween
when she had no costume, then "it turned
into a business." A fine arts graduate, she's
a former Hughes Helicopter receptionist
and sells hand-painted dresses on the
boardwalk. "I feel safe at night in Venice,"
she says—"if I'm skating fast enough."

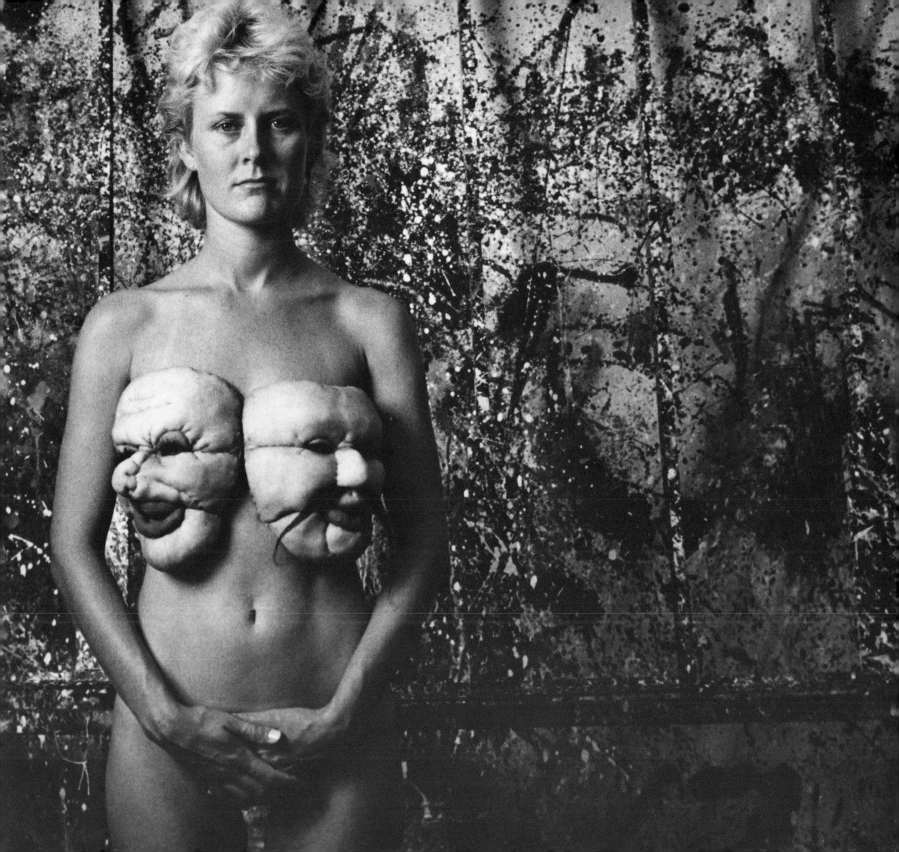

130 Larry Woods

Larry moved to Venice to be near the water,
"even though I can't swim." His best-
selling button reads, "Are We Having Fun
Yet?"

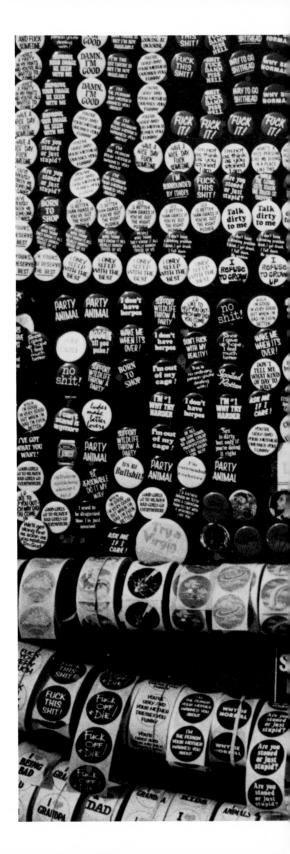

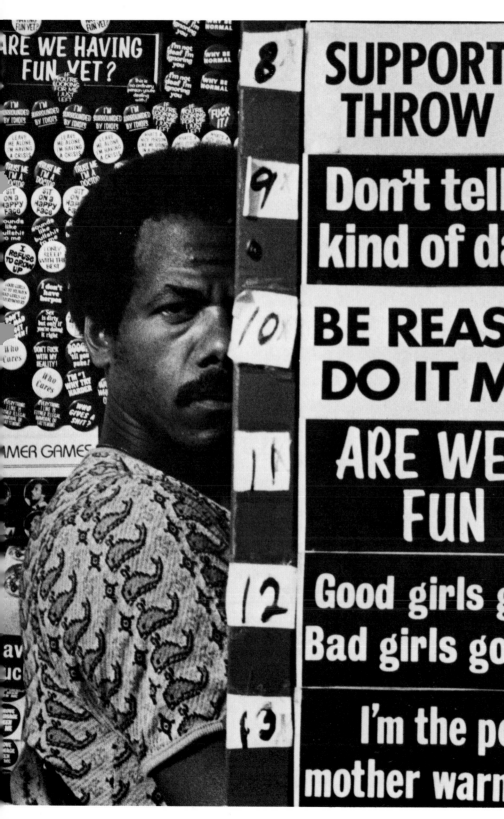

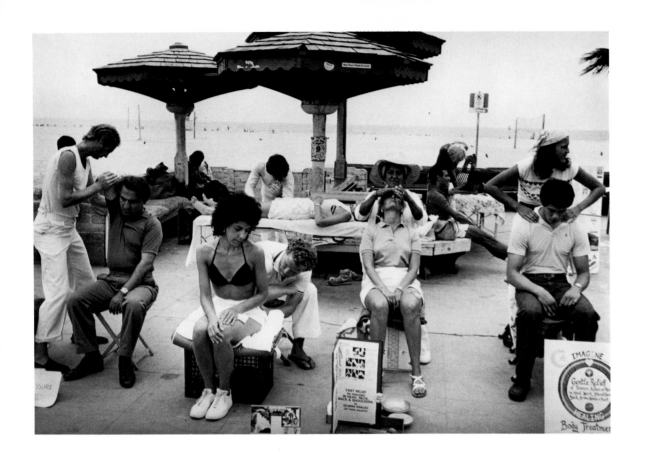

The Healers

*In exchange for a small donation, they
counsel people regarding diet, relaxation,
meditation, exercise, and will perform
healing, massage, and "sometimes mira-
cles," according to one of their patients.*

Edouard Owens

He writes poetry, plays the drums, and sleeps on the beach. Edouard has five kids and occasionally sleeps at home. "I'm trying to kick my alcohol habit, but I haven't been very successful," he confides.

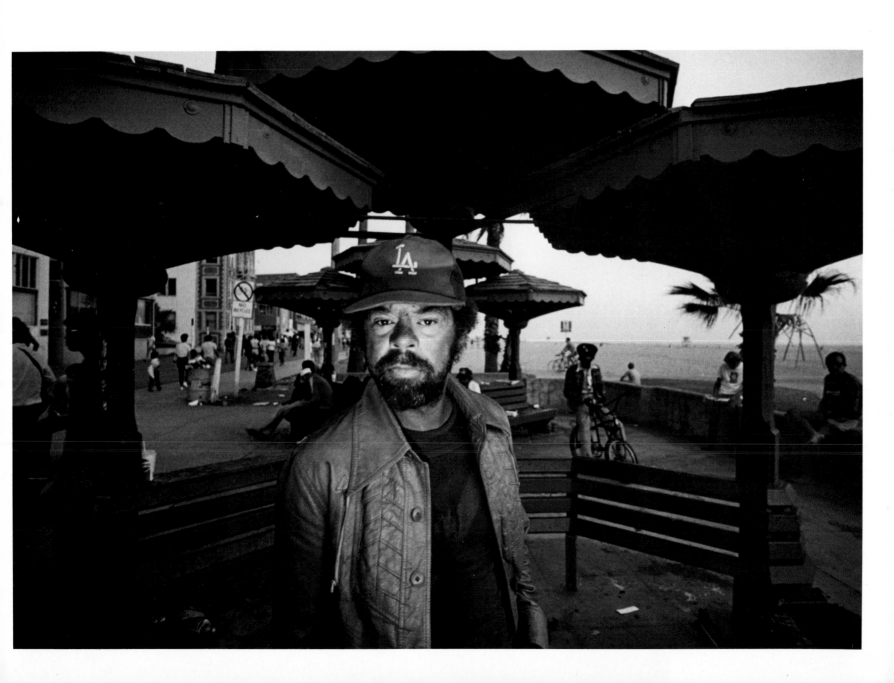

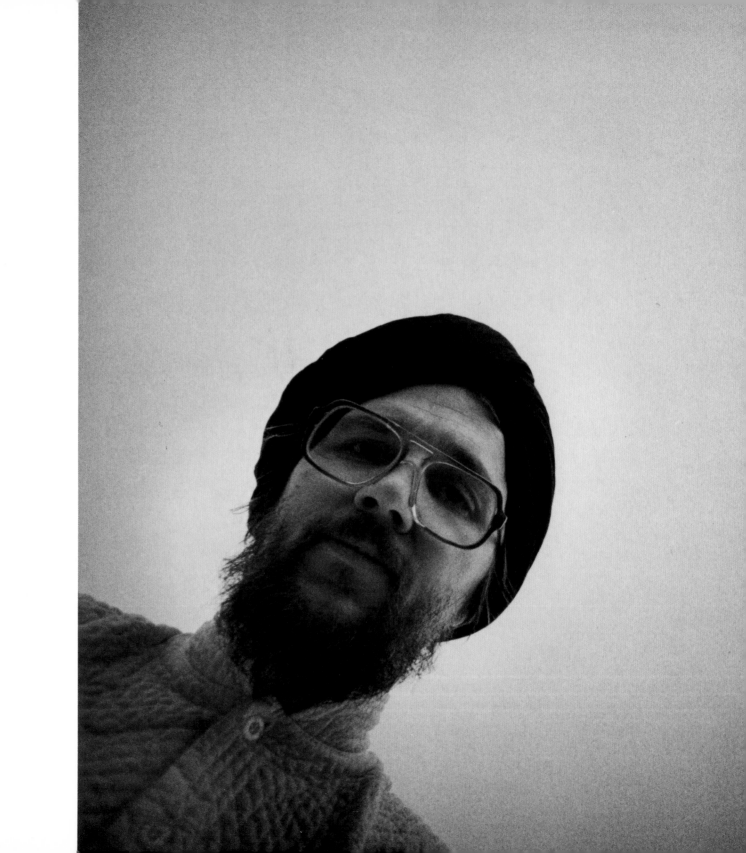

Datar Singh Khalsa

An electronics engineer, he has been a Sikh for the last four months. He does body massage and "deep tissue work" in exchange for donations. Datar is also a consultant for a computer firm. He has been married twice and has five children by three different women.

Rick Smith

He started carrying a gun at age thirteen.
After meeting Dashiell Hammett, Smith
decided to become a private detective. His
office in Venice faces the beach and has a
shower. As a child growing up in the
Bronx, he and his friends used to set cats
on fire and throw dogs off the roof—"just
for the fun of it."

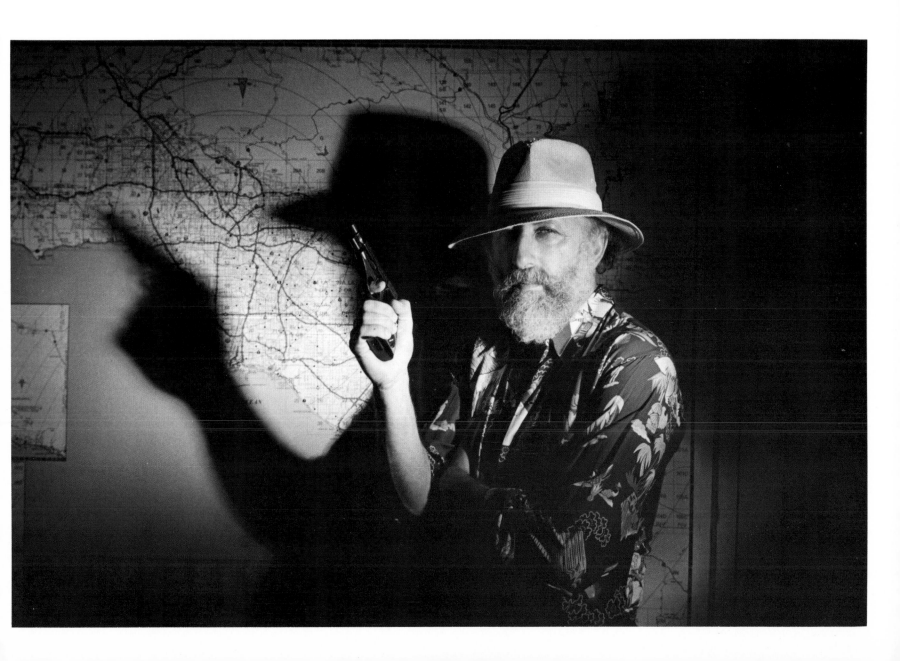

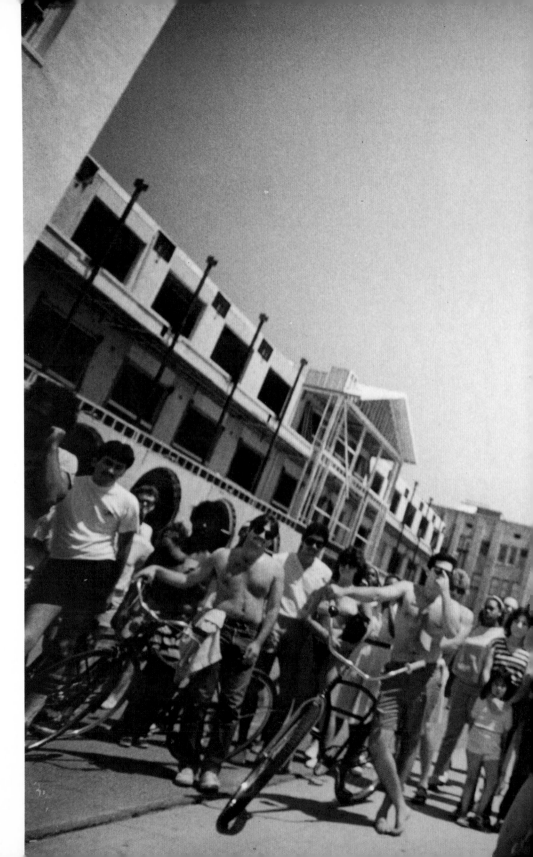

138 Jimmy Watts

He is a Rastafarian Nazarene and reggae composer from Maryland. He has written the song "Venice Beach Going Reggae": "Everybody get on down/ We don't want you to have no frown/ Let the music take your mind/ Leave all your troubles behind/ Venice Beach going reggae."

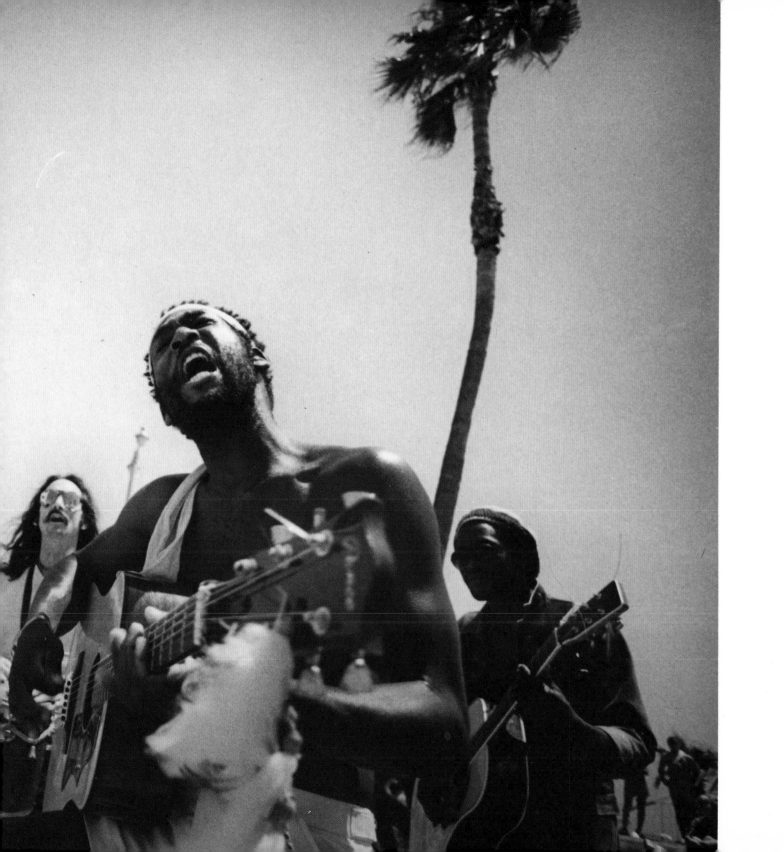

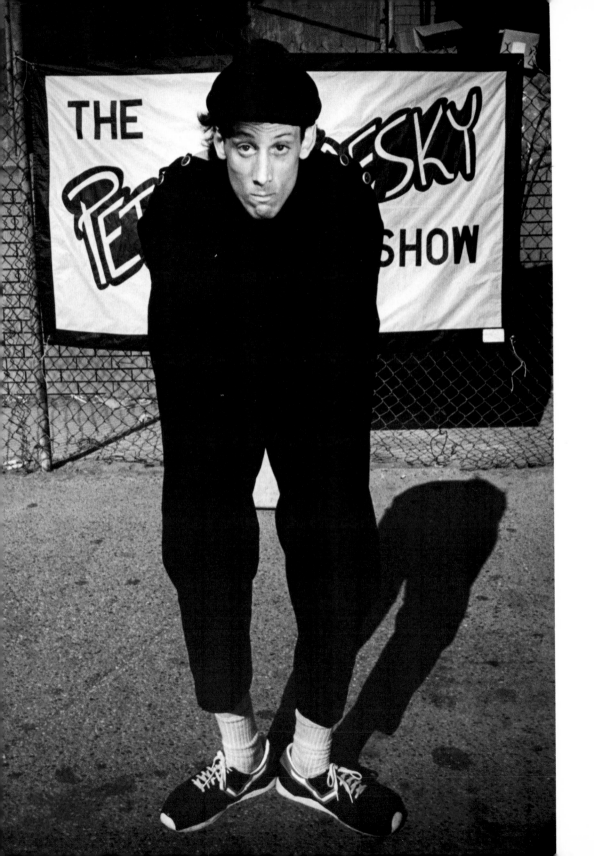

Peter Pitofsky

Of Polish origin, he is a twenty-five-year-old boardwalk comedian who dropped out of high school to become a Ringling Brothers clown. "My family is not into the circus," he says. "They are a circus. And me, I'm a Polish joke."

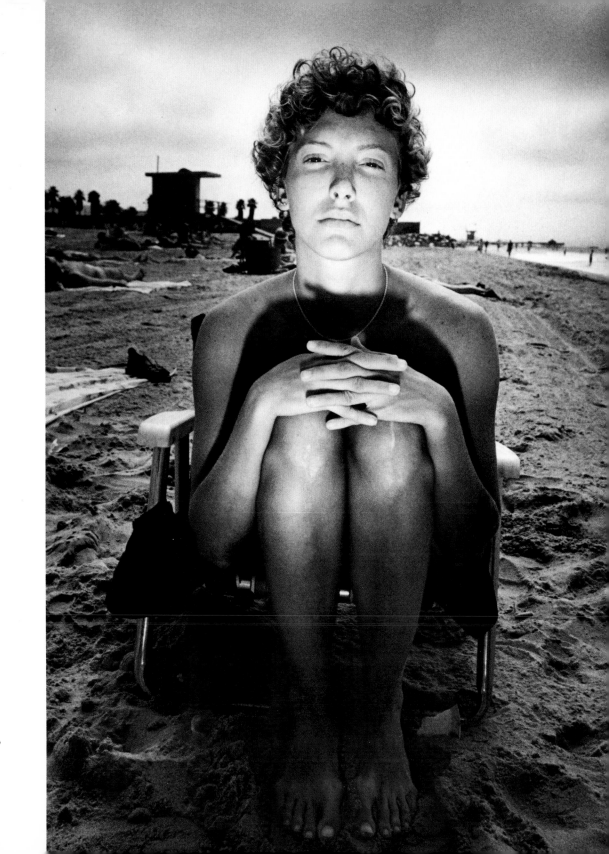

Linda Watts

*At age fifteen Linda discovered she was
sexually attracted to her female teachers.
Since then she has dated only women.
"I've never slept with any man," she says.
"But at twenty-seven I'm getting curious."*

142 Robert Gruenberg

*Robert juggles chainsaws while they're
running. A former used-car salesman,
commercials actor, and guest on the Johnny
Carson show, he bought a Porsche with
the money he's made juggling on the
beach. He's a Reagan supporter because
"any actor who can keep a job for more
than four years deserves my support."*

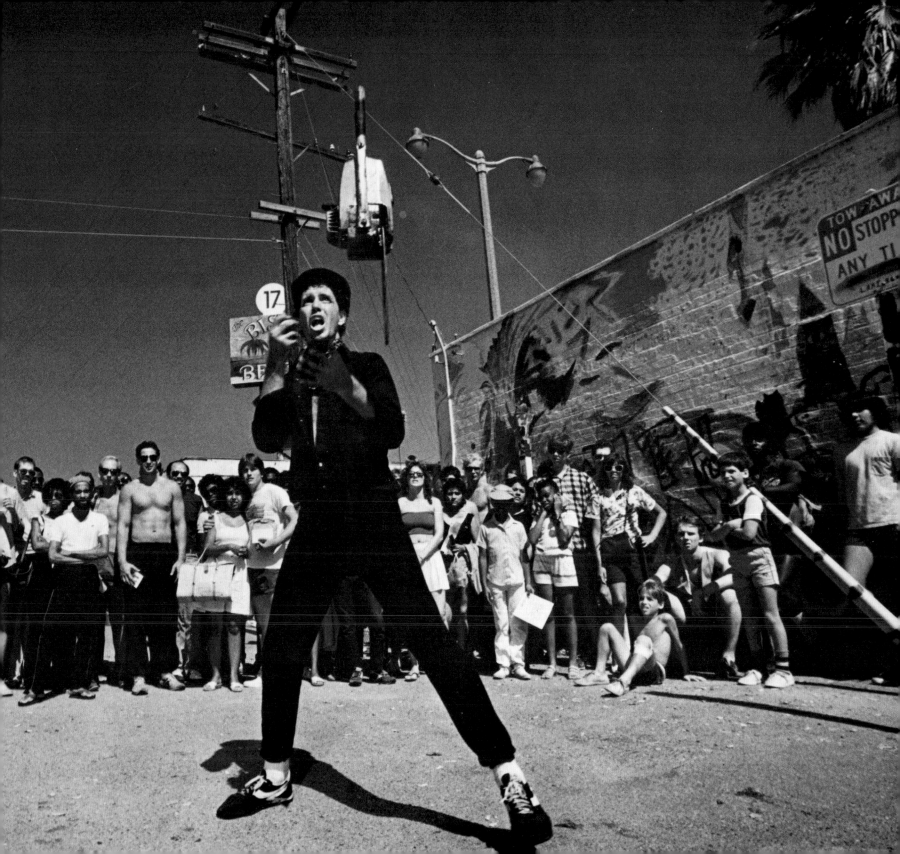

Tony Harrison

*He belongs to the 45-member East Coast
First Street Gang. Tony works with his
uncle as a mechanic and wants someday
to work for General Motors. He is wearing
a colorful plastic cap over his head because
"it's Saturday and I want to keep my hair
moist."*

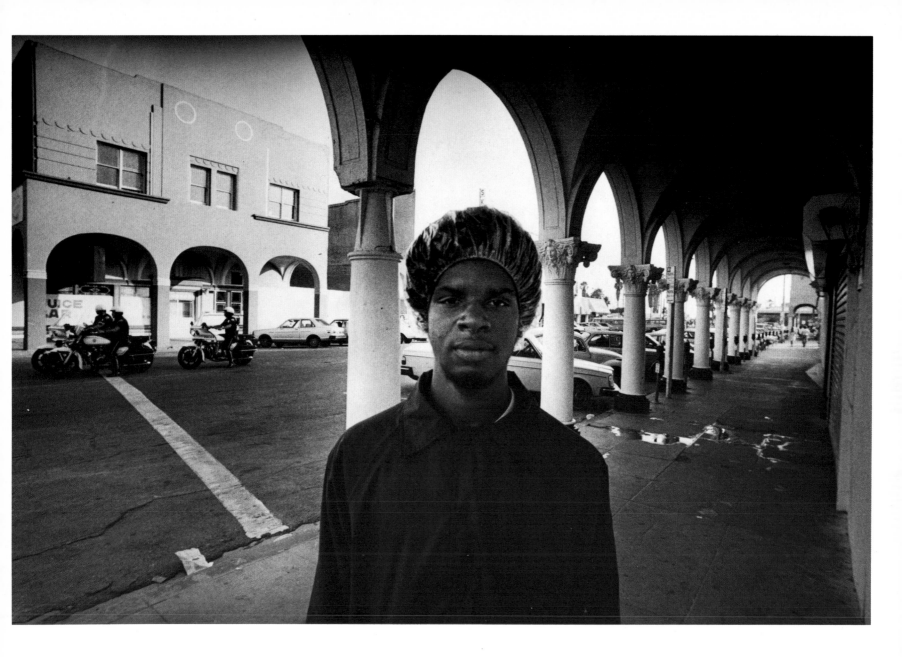

Steve and Kim Cameron

Steve started tattooing when he was nine, using a needle and a bottle of ink. He met his wife Kim, a former dentist's assistant, when she came for a tattoo. "Tattooing is my art. I don't care for oil paintings," he says. "It takes forever to make them."

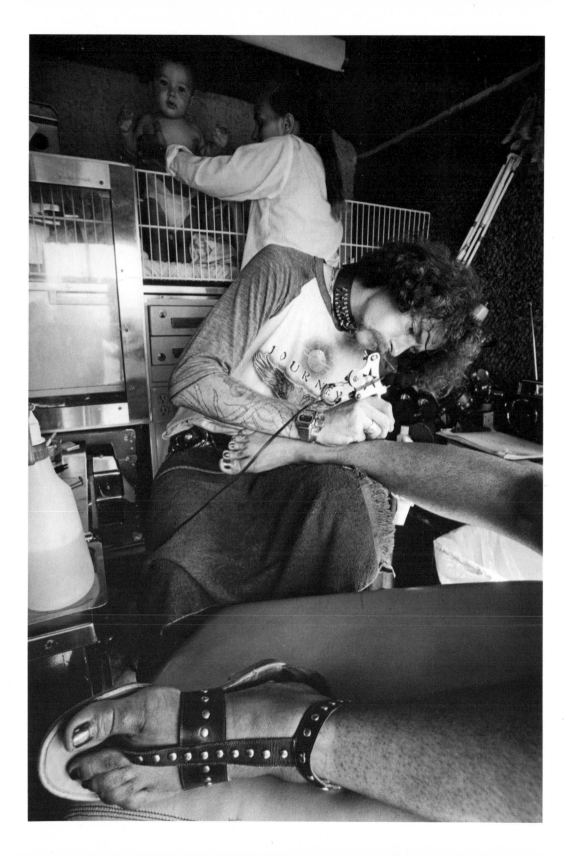

148 Maritza Mazariego

"I came to Venice because of the weirdos, the psychedelics, the Rastas, and all the colorful people," she says. A twenty-two-year-old Salvadoran, she wants to be a fashion designer and wealthy. "Practically everything I see in the windows, I want," she says. Presently, she works behind the counter at a health-food store.

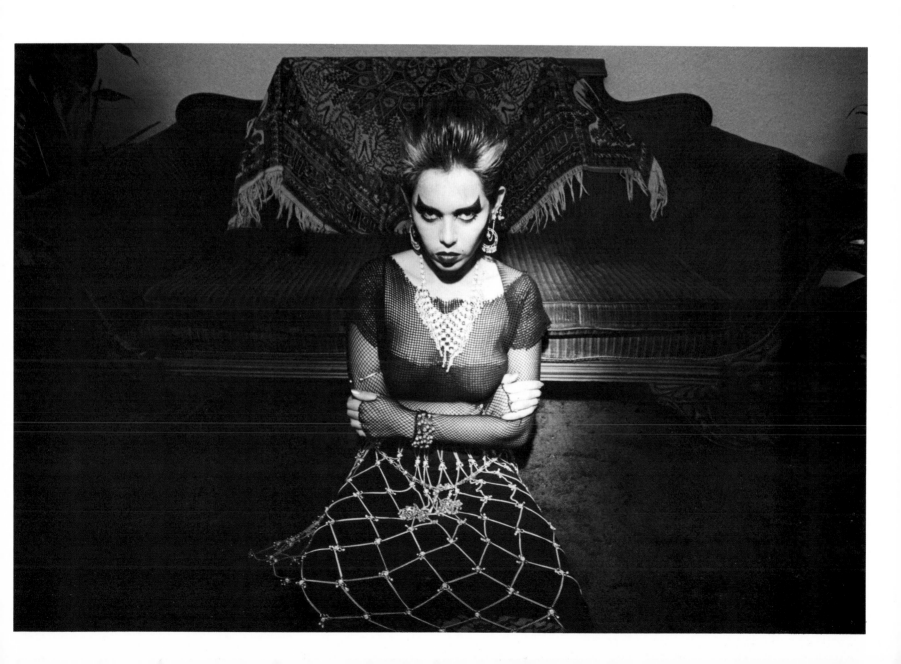

Muscle Beach

"If you are unemployed, you build up an inner anger. Working up your body, you get rid of it," says Rahim, a body builder.

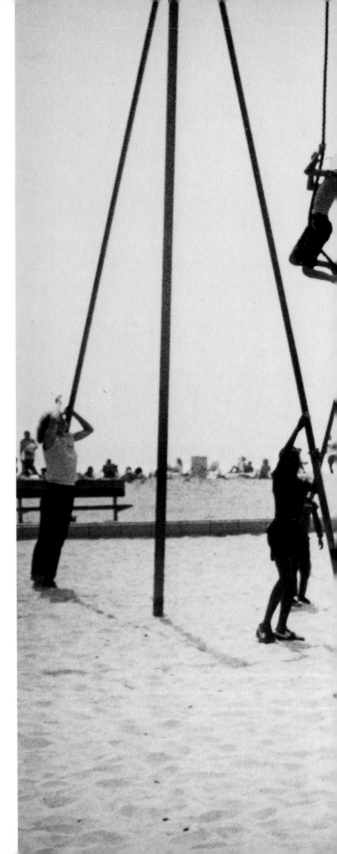

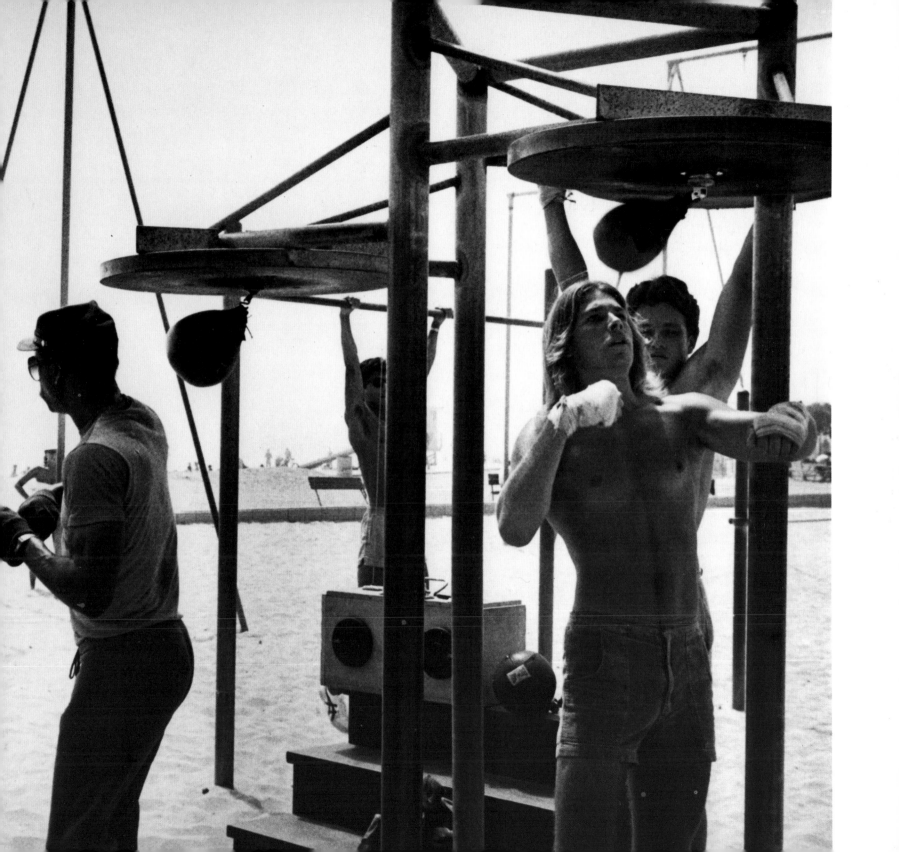

Guy Dill

A former painter, he switched to sculpture because "painting isn't real; it's not there physically." His work is in the collections of the Guggenheim Museum, the Museum of Modern Art in New York, and the Museum of Contemporary Art in Los Angeles.

Annette Stewart

A former professional surfer, she once won the East Coast Championship. She started surfing at age seven, and now wants to be a cosmetologist.

Boardwalk

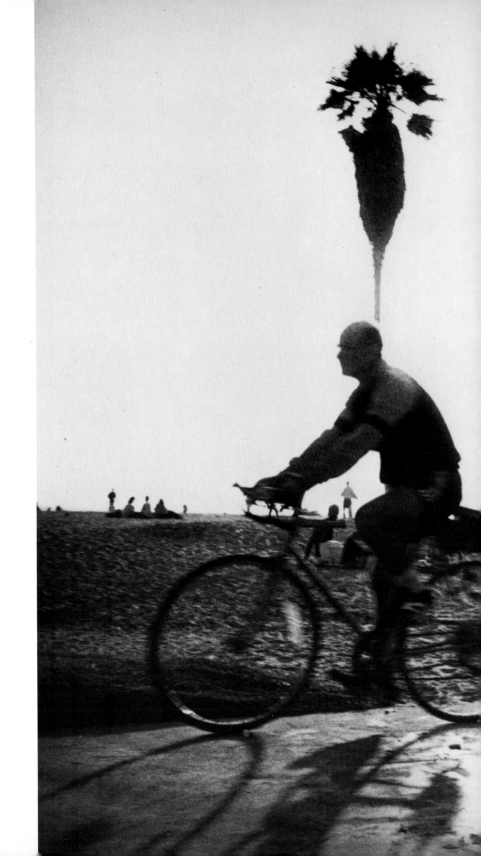

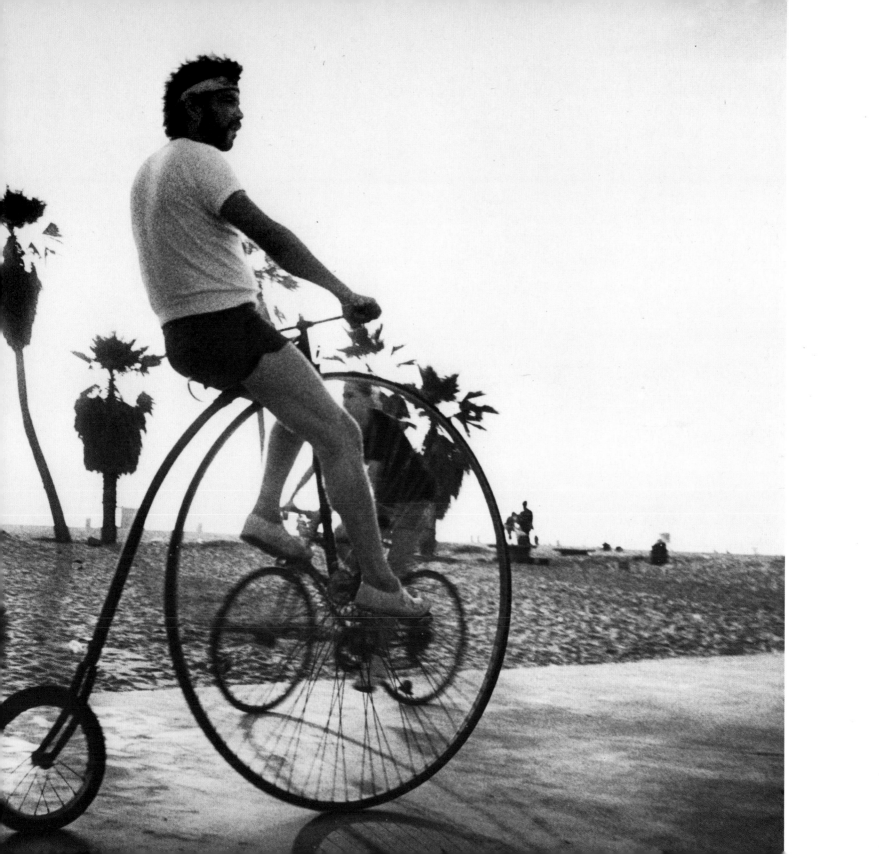

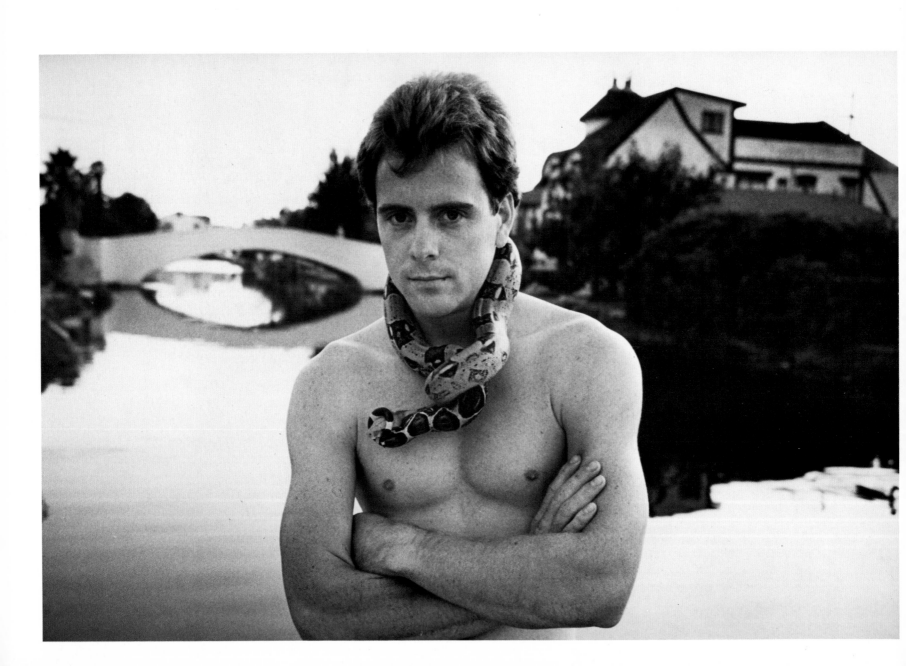

Thayer works for AT&T, installing and repairing phones and computers. A Santa Monica native, he believes snakes are the world's best pets. "They're clean. They eat only once every two weeks (live rats), and defecate about twice a month."

Curtis

After his home was burglarized, this twenty-
nine-year-old heavyweight boxer tracked
down the thieves, "punched them out,"
and got back his stereo, microwave oven,
and typewriter. "Living in Venice made a
boxer out of me," he says.

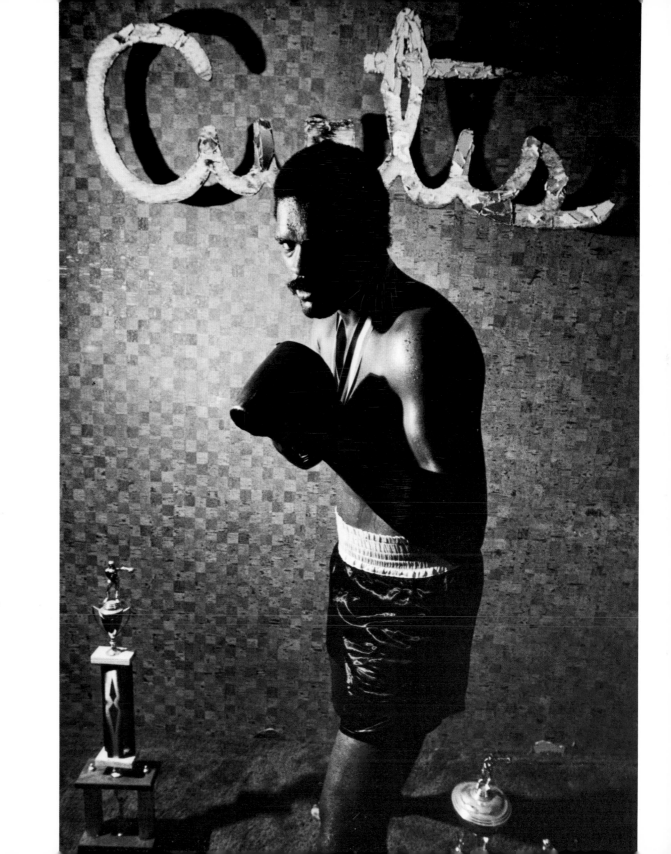

John La Piantre

An ex-Navy diver, La Piantre is a wall painter. "I tried canvas painting," he says, "but all I got was a glorified stick man." He appreciates the people of Venice, "because they do not beg for their money —they perform for it."

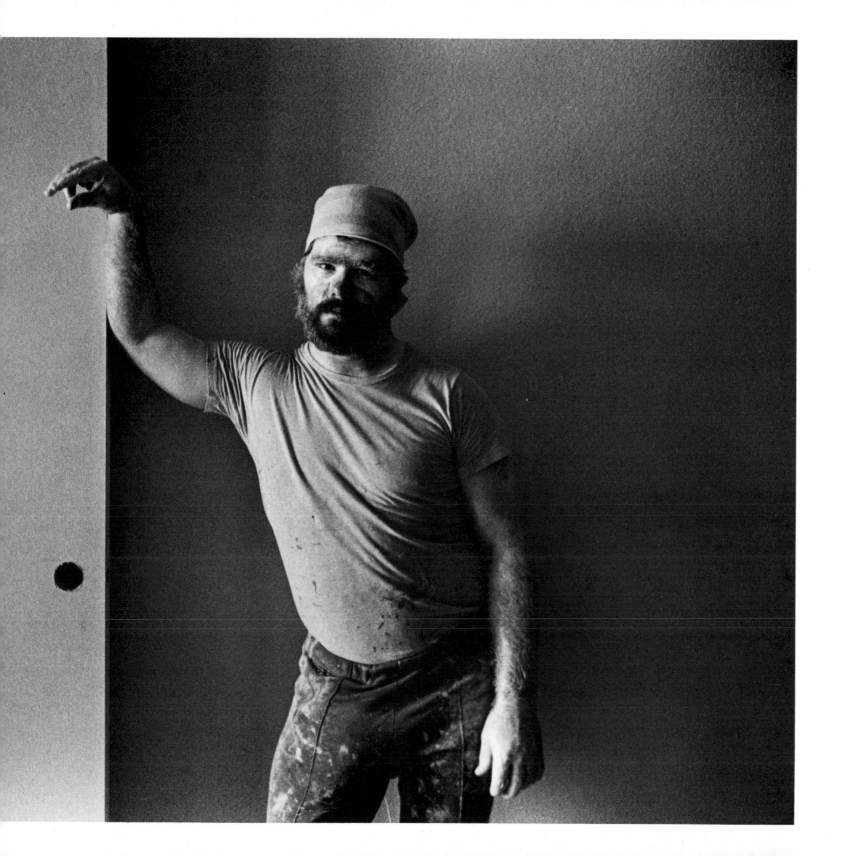

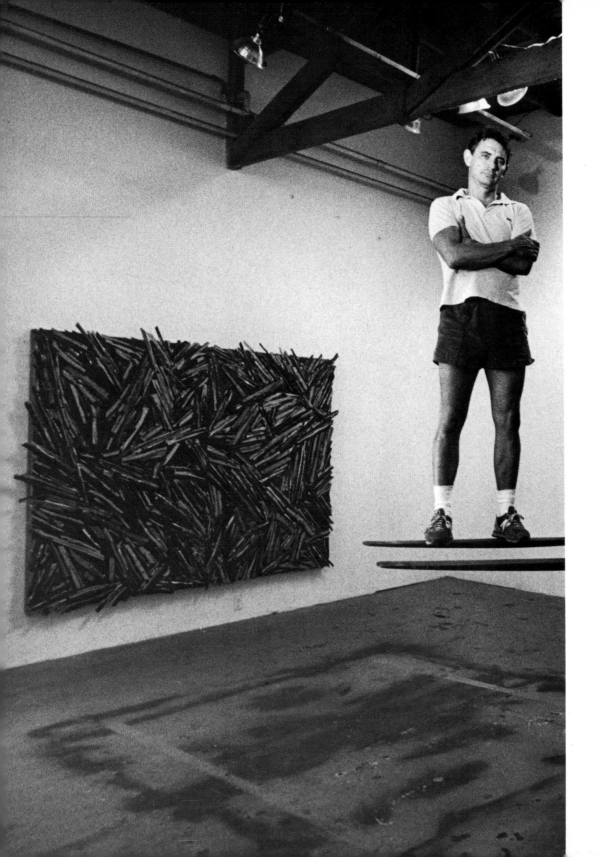

Charles Arnoldi

"Venice is like a zoo where people piss on your door," he complains. A painter and sculptor, he claims, "There is no respect for your parking space in this town." He thinks the political activists drove a lot of good people out of Venice. The result, according to Arnoldi, was that a number of real estate profiteers moved in.

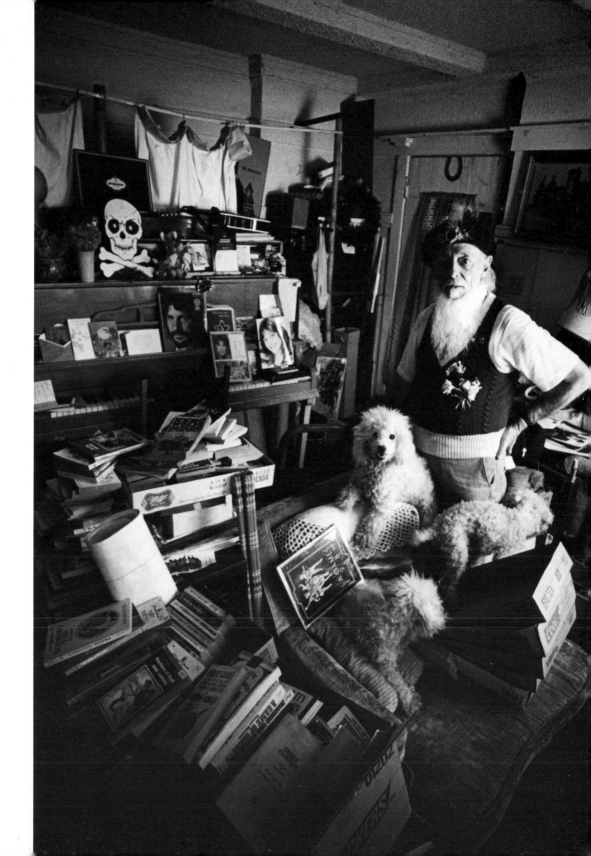

Domenick Covolo

*He claims to be the town's oldest "double
Venetian." He was born in Venice, Italy,
ninety years ago and has been a chef in
many restaurants, including Sardi's in
New York. Currently he is an advertising
model and was featured in a 1984 Olym-
pics poster. His most vivid memory of
Venice, California, is of the day his house
collapsed on him.*

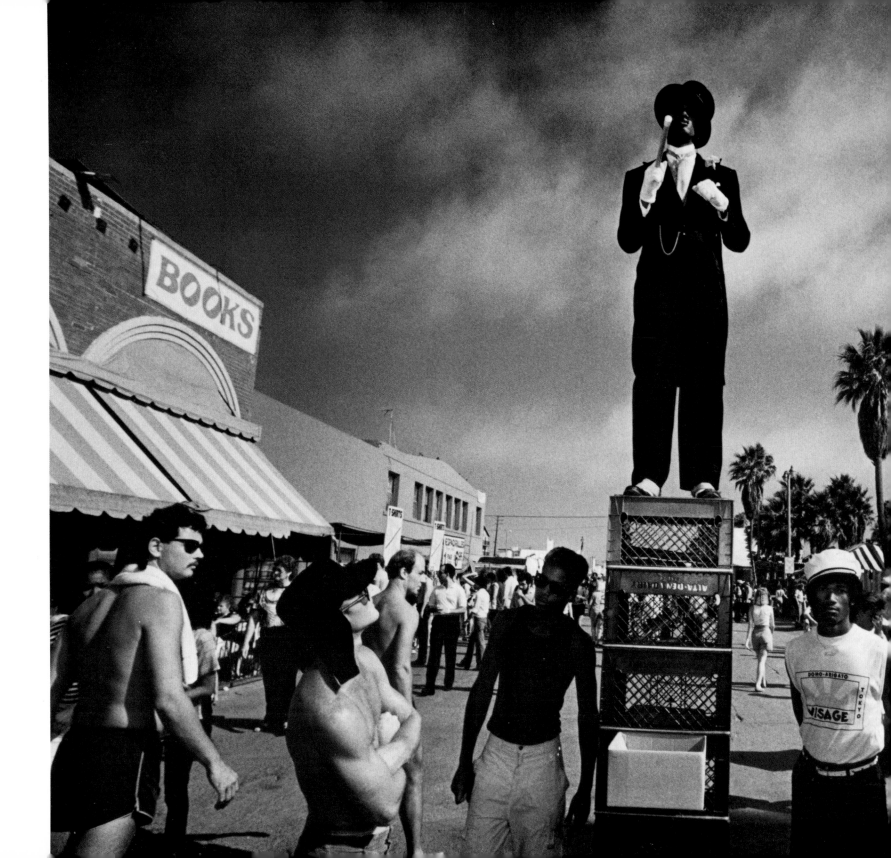

Marvallier Gordon

"I'm a neo-impressionist artist statue from the 17th century," Gordon says. Born in Virginia, he learned to stand still in the Philippines. He can stand motionless for more than two hours. He's also a Kung Fu expert, a comedian, and a ventriloquist.

Arjuna Hillman Bowie

*"Venice is the best beach to boogie board,"
he asserts. Nine years old, he wants to be
a veterinarian.*

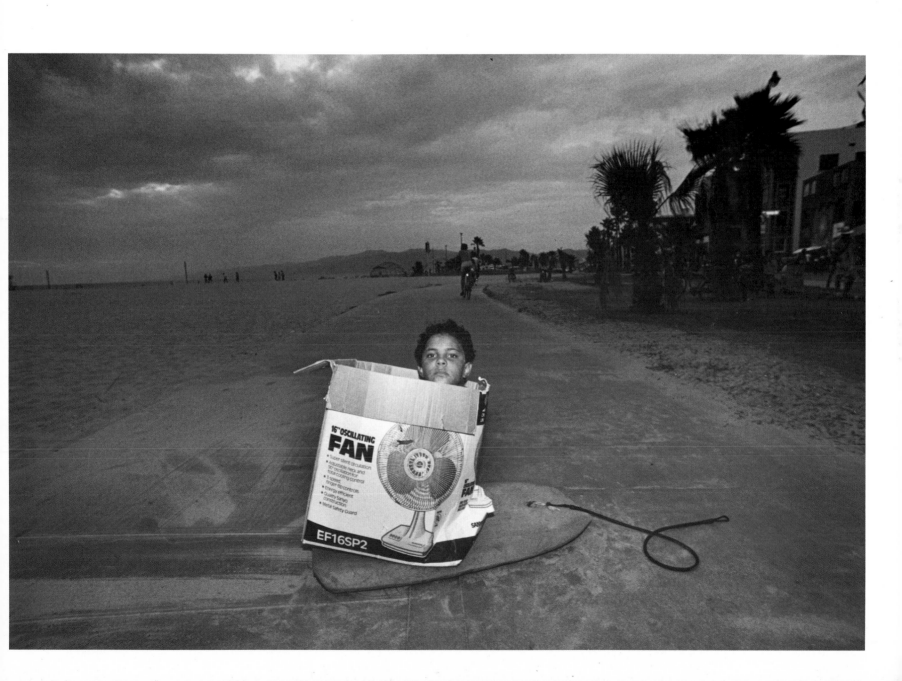

ABOUT THE PHOTOGRAPHER

Claudio Edinger is the author of the award-winning Chelsea Hotel. *He teaches photography at* The New School For Social Research, *and his work has been published in* Time, Newsweek, The New York Times, Fortune, Vogue, Playboy, *and* American Photographer. *His work has been exhibited at the International Center of Photography, Photographer's Gallery, Centre national d'art et de culture Georges Pompidou, and Museo de Arte de São Paulo. He is a member of Gamma-Liaison and Kay Reese and Associates.*